IMAGES
of England

BEXHILL-ON-SEA

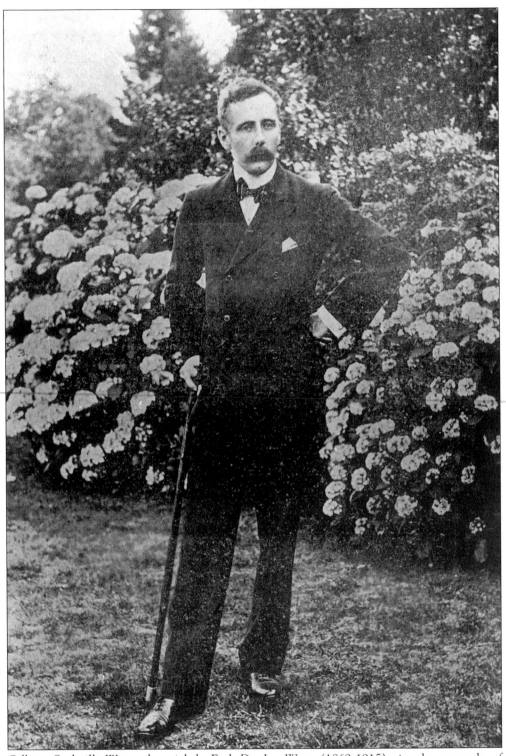

Gilbert Sackville-West, the eighth Earl De La Warr (1869-1915), in the grounds of
Normanhurst Court, the home of the Brassey family at Catsfield, c. 1900.

IMAGES
of England

BEXHILL-ON-SEA

Compiled by
Julian Porter MA

TEMPUS

First published 1998
Copyright © Julian Porter, 1998

Tempus Publishing Limited
The Mill, Brimscombe Port,
Stroud, Gloucestershire, GL5 2QG

ISBN 0 7524 1144 6

Typesetting and origination by
Tempus Publishing Limited
Printed in Great Britain by
Midway Clark Printing, Wiltshire

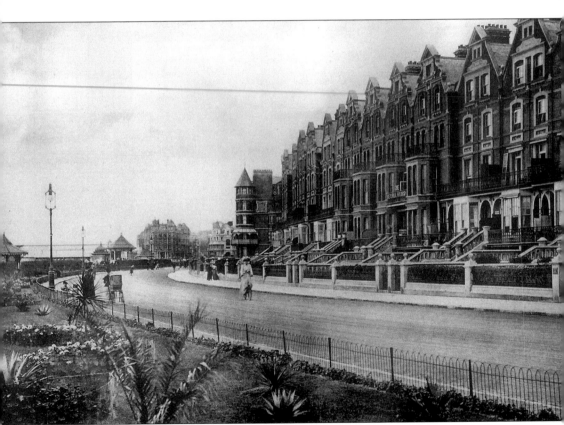

De La Warr Parade, *c*. 1904. The sign in the middle of Marine Mansions reads 'The Bexhill Hydro'; this establishment was run by Miss Brook and offered hydropathic treatment to visitors. Such facilities were in keeping with Bexhill's reputation as a health-giving resort.

Contents

Acknowledgements

I would like to thank the following people for their help:
Alan Beecher, Bexhill Museum Association, Margaret Cullingworth, Peter Mepham, Heather Morrey, Don Phillips, John Porter, Rother District Council Reprographics Division, Rother Museum Service, Mr L.H. Sivyer, Ann Vollor, and all the people who have donated old photographs to Bexhill Museum in the past.

Julian Porter MA, 1998

Bibliography

Bexhill Chronicle Directory & Almanack: various issues
Gray, F. ed. *Bexhill Voices* CCE University of Sussex (Falmer) 1994
Guilmant, Aylwin *Bexhill-on-Sea: A Pictorial History*: Phillimore (Chichester) 1982
L.J. Bartley *The Story of Bexhill*: F.J. Parsons Ltd (Bexhill-on-Sea) 1971
Mullens, W.H. *A Short History of Bexhill* (Bexhill) 1927
Porter, J. *Annie Lady Brassey 1839-1887* (Bexhill) 1996

Further details of many of the characters and events of Bexhill may be found in L.J. Bartley's *The Story of Bexhill* (1971) and his many articles in the *Bexhill Observer* which have provided much information for the preparation of this book.

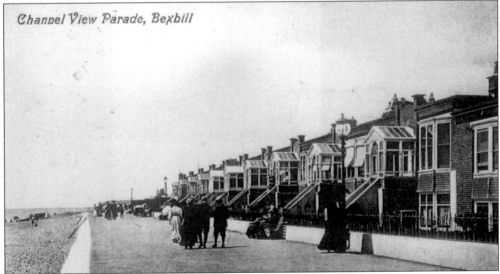

Channel View Parade, the seaward side of Marina Arcade, *c.* 1910. Marina Arcade and Bazaar were built in 1905. There was an intention to construct a pier on the site but, like all the other pier proposals for Bexhill-on-Sea, it was never built.

Introduction

This book draws upon the wealth of archival material stored at and cared for by Bexhill Museum. For the most part, the original photographs were donated by people so that, rather than lying abandoned in a forgotten box or album, they could instead be shared with everyone who is interested in seeing what Bexhill looked like in the past.

Bexhill's first inhabitants were the dinosaurs whose 130 million-year-old fossilized bones and footprints are sometimes found on the beach, much to the delight of local children. The first signs of human activity in the area are in the form of Mesolithic microliths, tiny flint blades which were used to fashion tools some 8,000 years ago. Neolithic and Bronze Age artefacts have also been discovered, some of which are associated with the submerged forest which is occasionally exposed at low water.

The oldest documentary reference to Bexhill is in a charter of King Offa of AD 772 which endowed a church and granted it to Bishop Oswald of Selsey. St Peter's church is Saxon in origin and contains the Bexhill Stone, a late ninth- or early tenth-century carved slab which was discovered under the nave when the church was altered in 1877. The Domesday Book records that Bexhill was laid waste in 1066, almost certainly by William the Conqueror *en route* to Hastings after making landfall near Pevensey.

Bexhill Manor was owned by the bishops of Selsey from 772 until it was seized by William the Conqueror in 1066 and given to Robert, Count of Eu. The see was moved to Chichester in 1075 and in 1148 the Manor was handed back to the bishops of Chichester by Robert's grandson John, Count of Eu. In 1561 the bishopric became vacant and ownership of the manor passed to Queen Elizabeth I. She in turn granted it to Thomas Sackville (later Baron Buckhurst and Earl of Dorset) in 1570.

From 1804 until 1814 Bexhill was home to a regiment of soldiers from Hanover, the King's German Legion, which became part of the British army during the Napoleonic wars. The fifth Duke of Dorset died in 1843; his daughter and heir Elizabeth Sackville had married George West, the fifth Earl De La Warr, in 1813 and it is through this marriage that Bexhill Manor came into the possession of the Earls De La Warr who did much to promote the town.

The Manor House, or Court Lodge as it was originally known, dated back to the thirteenth century and was used as a residence by the bishops of Chichester when visiting the area. It is thought to have replaced a house granted to the Church by Robert de Creol in the eleventh century. Bishop Adam de Moleyns obtained a licence to fortify the Manor House and to impark some of the surrounding land, probably Buckholt, in about 1450. When the Sackvilles acquired

the manor they used the Manor House as a hunting lodge rather than a home as their main residence was at Knole in Kent. The Brook family, who acted as bailiffs for the lord of the manor, occupied the Manor House during much of the nineteenth century. Arthur Sawyer Brook was known locally as 'Squire' Brook although the title was unofficial and he was once described as 'arch-Tory and sometime king of Bexhill'. The eighth Earl and Lady De La Warr renovated and lived in the manor house from 1891 until their divorce in 1902. Following the divorce the house was leased to August Neven Du Mont and after the First World War to Sir Robert Leicester Harmsworth who stayed there with his family until 1963. The Manor House was purchased by Bexhill Corporation and demolished in 1968.

The original Bexhill, or the Old Town as it is now known, was set on a hill inland and still has quite a different character to the seafront development of 'Bexhill-on-Sea'. The seaside aspect of the town is late Victorian. A sea wall was built by John Webb for the seventh Earl De La Warr in 1883 and the development of the resort began soon after.

One of Bexhill's many claims to fame was that it was the first place in Britain officially to permit mixed bathing, in 1901. It was Viscount Cantelupe, who became the eighth Earl De La Warr in 1896, who really developed Bexhill-on-Sea. He wanted to promote the town as a fashionable resort and built the Kursaal as a high-class entertainment venue that held performances by some of the leading artistes of the period. The Earl constructed a cycling boulevard on the seafront in 1896 and this was later used as Britain's first international motor-racing track in 1902, which coincided with the incorporation of Bexhill as a borough.

The ninth Earl De La Warr was the town's first socialist mayor and he was responsible for persuading the council to build the De La Warr Pavilion in 1935. This replaced the Kursaal and was Britain's first example of a welded steel-framed public building in the 'International Modernist' style.

During the First World War soldiers were stationed at Cooden Camp; these included part of the Royal Sussex Regiment and Canadian and South African troops. During the Second World War children from London were evacuated to Bexhill but when it became apparent that this part of the coastline was a likely place for an enemy invasion the town was evacuated. Bexhill became famous for its independent schools which made a significant contribution to the town's economy. Many of the children boarded at the schools while their parents were overseas, thus giving rise to links between Bexhill-on-Sea and the colonies. Many of the schools did not reopen after the Second World War and their grounds and playing fields were developed as housing estates.

Local government in the town was radically changed in 1974 when Bexhill became part of Rother District Council and the Town Hall became the centre of administration for the District rather than just Bexhill. When the independent schools closed, their grounds and playing fields were soon covered with new houses. Many people, including ex-pupils, retired to Bexhill, which gradually became less of a resort and more residential in character. Recently, with much local effort, projects such as the restoration of the De La Warr Pavilion and the work of the Bexhill Regeneration Partnership have begun to revitalize the town and to generate greater interest in its heritage.

One
Portraits and Groups

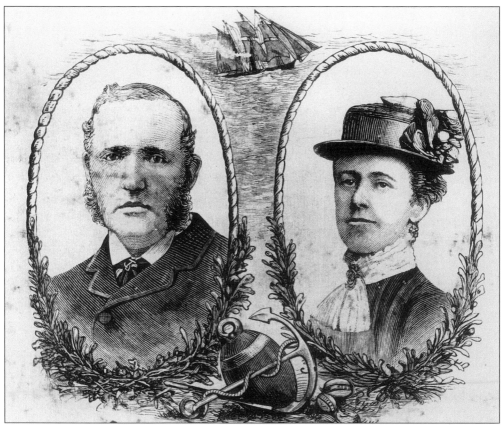

Thomas (1836-1918) and Annie Brassey (1839-1887), c. 1878. The Brasseys were famous for their circumnavigation of the globe in 1876-77. Annie published their adventures as *A Voyage in the Sunbeam*, which became a Victorian bestseller. Annie collected objects from all around the world to create her own museum. Some of her collections are now in Hastings and Bexhill Museums. Thomas Brassey purchased land at Buckholt and so became involved with the affairs of Bexhill. In 1891 his daughter Muriel married Viscount Cantelupe, the future eighth Earl De La Warr.

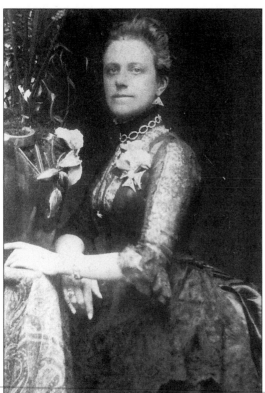

Annie Brassey, *c.* 1881. Annie formed a Bexhill Centre for the St John Ambulance Association in 1883 and did much to promote the Association worldwide. Annie died at sea in 1887 on the return leg of a long voyage to Australia on the Brasseys' steam yacht *Sunbeam*. Her account of the journey was published as *The Last Voyage*.

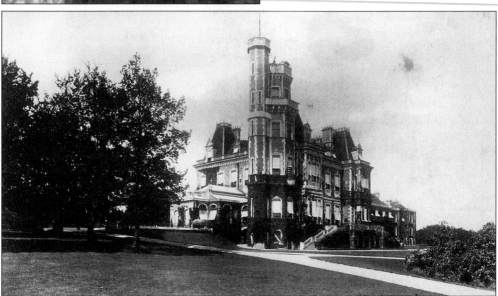

Normanhurst Court, Catsfield, the home of the Brassey family, *c.* 1880. It was built between 1868 and 1870 on land that had formerly been part of the Ashburnham estate. During the First World War it was used as a military hospital and from 1922, after the death of Thomas Allnutt Brassey, the second and last Earl Brassey, it became St Hilary's School for girls. It was damaged through use as a prisoner of war camp during the Second World War and was finally demolished in 1951.

Viscount Cantelupe (1869-1915), first chairman of Bexhill District Council in 1894. In 1896 he became the eighth Earl De La Warr.

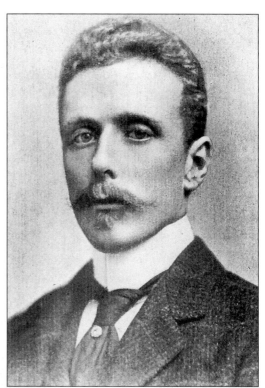

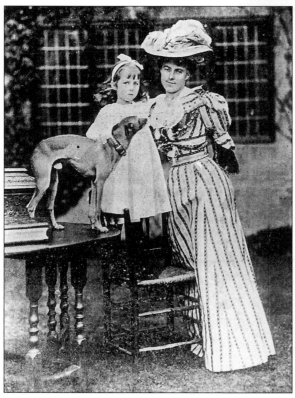

Muriel Agnes, Countess De La Warr, *née* Muriel Brassey (1872-1930), with her daughter, Lady Myra Sackville, at the Manor House, *c*. 1900.

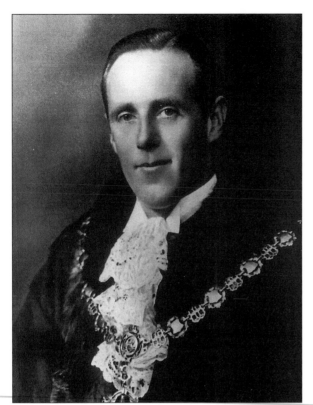

The ninth Earl De La Warr (1900-1976) wearing the mayoral regalia, c. 1932. He was Bexhill's only socialist mayor, holding office between 1932 and 1935. After his parents divorced in 1902 he lived with his mother and grandfather, Lord Brassey, at Normanhurst Court. His father died in 1915 and his mother, Countess De La Warr, presided over the manorial court until he came of age in 1921. He was a conscientious objector in the First World War and an active supporter of the Labour Party through which he pursued a political career as a parliamentary secretary.

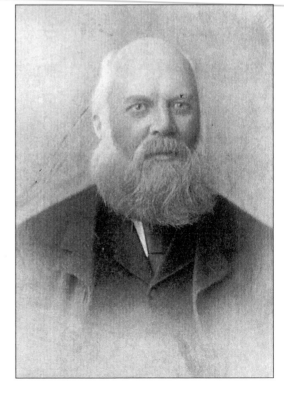

Councillor J.W. Webb, the builder of Bexhill. In 1883 John Webb was contracted by the seventh Earl De La Warr to build a sea wall and promenade from Galley Hill to the bottom of Sea Road. In part payment Webb received land south of the railway line from Sea Road to the Polegrove. He developed this land as the Egerton Park Estate and built the west promenade in 1886. He died in 1922.

Arthur Sawyer Brook, Master of the Bexhill Harriers pack of the now extinct Southern hounds, in 1888. He was known locally as 'Squire' Brook although he never officially received the title. His family founded the Bexhill Harriers in 1785 and they were disbanded in 1913. When Squire Brook died in 1890, his son sold the pack to Viscount Cantelupe who built new kennels at Cooden.

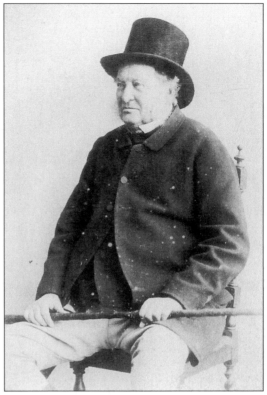

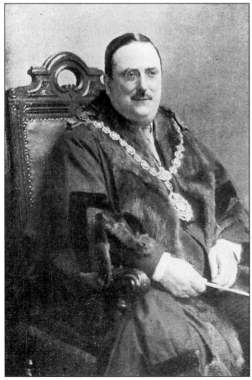

Jimmy Glover, when he became mayor in 1906. Glover was best known as the manager of the Kursaal and helped the eighth Earl to organize many of the town's social events, including the 'Pink Domino Ball' after the 1902 motor races.

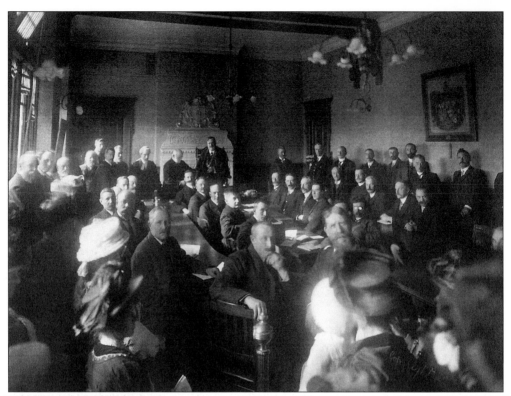

Lord Brassey receiving the Freedom of the Borough from the outgoing mayor Jimmy Glover, 9 November 1907. Lord Brassey was the first person to receive this honour and shortly afterwards he was elected mayor.

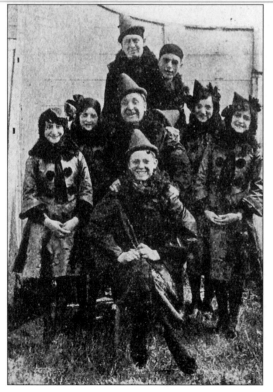

The Coronets, c. 1914. The Coronets were Pat Kinsella's concert party which performed at the Kursaal, the Lawn (now part of the De La Warr Pavilion car park) and later at the Bijou which was managed by Pat Kinsella and Harry Collard.

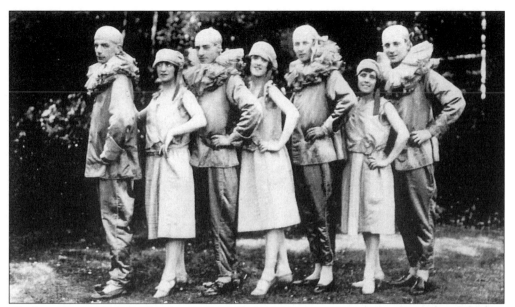

The Poppies, 1925. As well as bands, Bexhill also had concert parties and pierrots to entertain its visitors, starting with the Olympia Quartet in 1900. There were also Cardow's Cadets and Pat Kinsella's Coronets. The Poppies of Will Tissington and Katherine Craig were the last concert party, who performed into the 1930s.

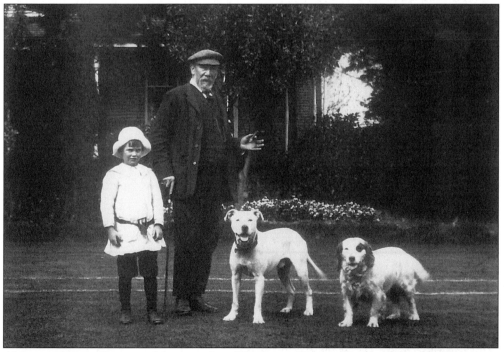

Alderman Henry Young and his grandson Harvey at Cooden Mount, 1900. The dogs were called Bobs and Scottie. Henry Young was an iron founder and his Pimlico foundry cast the metalwork for the Sackville Arch when it was widened in 1892.

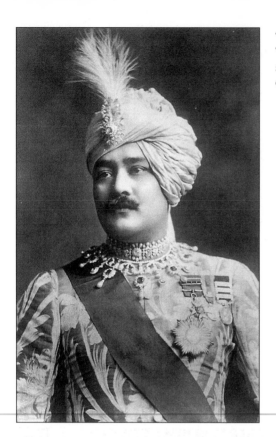

The Maharajah of Cooch Behar, *c.* 1905. The Maharajah came to Bexhill in 1911 in an attempt to recover his failing health but died shortly afterwards.

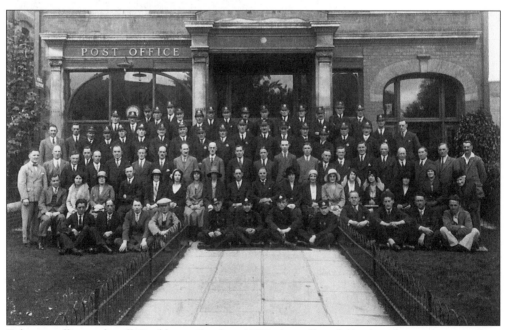

Sub post office and staff, Buckhurst Road, *c.* 1920. As well as delivering the mail, post offices also operated the telegraph service.

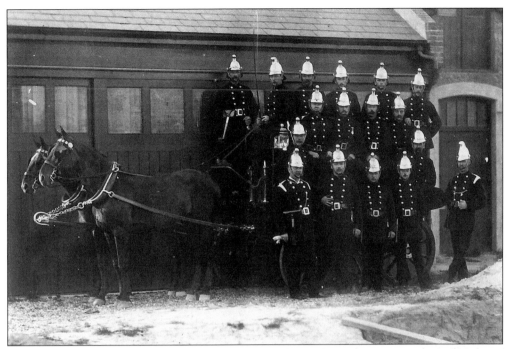

Bexhill Fire Brigade, *c.* 1892. A volunteer fire brigade was formed in 1888 and in 1900 it was taken over by the Local Board. As well as putting out fires, the brigade formed a guard of honour at local events. The first fire station was in Devonshire Square, but from 1896 until 1971 it was in Amherst Road, behind the Town Hall.

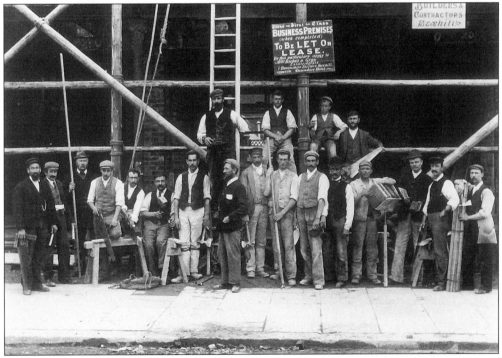

Builders outside the site that later became Longley Brothers Ltd, Devonshire Road, *c.* 1903.

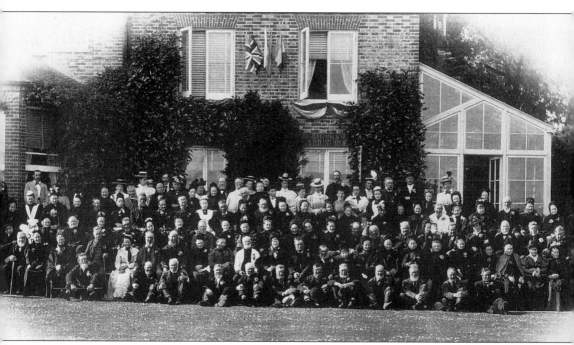

Queen Victoria's Diamond Jubilee celebrations at Woodsgate, Bexhill, 23 May 1897. The Woodsgate estate was owned by John Lambert Walker. He built four almshouses in Crowmere Avenue, a Working Men's Club in Holliers Hill and provided the land and paid for the building of St Stephen's church. He moved to Bexhill in 1875 and died in 1903.

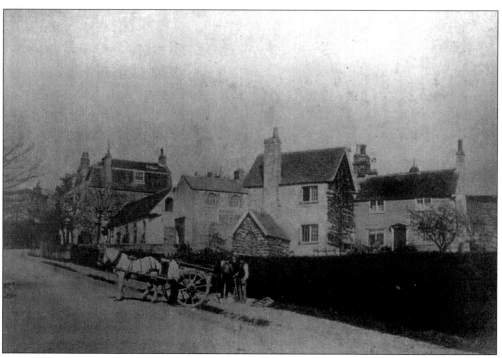

Belle Hill, *c.* 1897, before the construction of Amherst Road in 1898.

Two
Bexhill Old Town

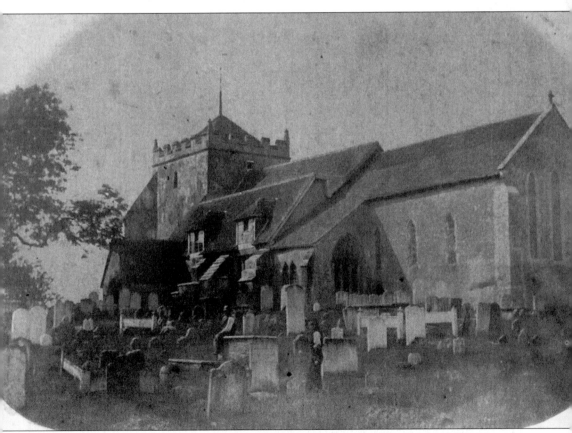

St Peter's church, *c.* 1875, as it appeared before the 'restoration' undertaken in 1878. Note the curious dormer windows on the south side. The church is Saxon in origin but whether it stands on the same site as the church endowed by King Offa in AD 772 is uncertain.

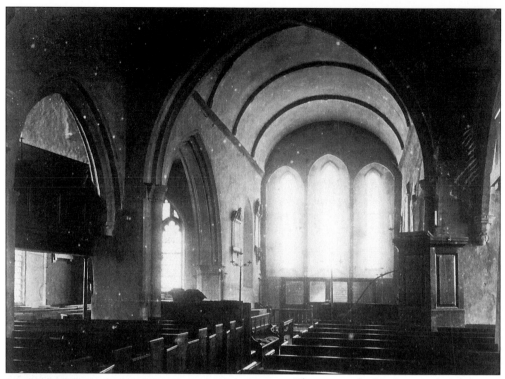

The east end of St Peter's church, *c.* 1877. During the 'restoration' of 1878 an intricately carved slab was found under the nave. The date of the 'Bexhill Stone' is possibly eighth century but may date from the ninth or even the early tenth century, so it may not relate to King Offa's church of AD 772.

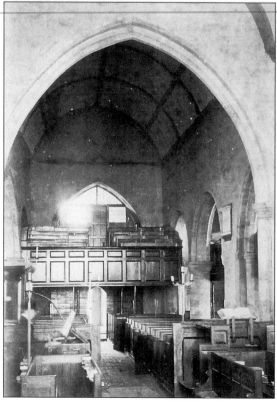

The west end of St Peter's church, *c.* 1877. The tower is believed to be Norman and the nave Saxon. This shows the eighteenth-century gallery that was removed in the 1878 restoration.

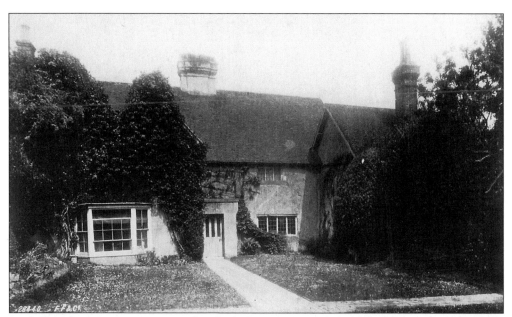

Bexhill Manor House in 1891, shortly before it was refurbished for Viscount and Lady Cantelupe. Prior to this the Manor House building was known as Court Lodge.

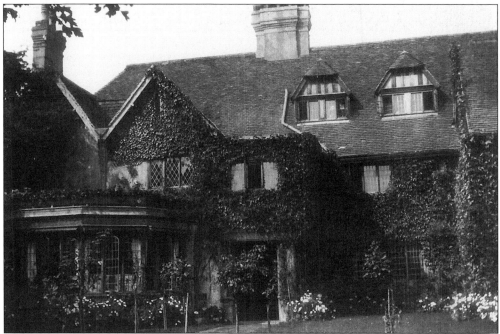

The Manor House from the south, 1907. Originally built for the bishops of Chichester, it was later used by the Dukes of Dorset as a hunting lodge. The Brook family lived there during most of the nineteenth century but eventually moved out due the building's disrepair. In 1891 it was renovated for the newly wed Viscount and Lady Cantelupe but after their divorce in 1902 it was let to the Du Mont family who further extended the building. After the First World War it was bought by Sir Robert Leicester Harmsworth, whose elder brother founded the *Daily Mail* and also took part in the 1902 races. Sadly the Manor House was demolished in 1968.

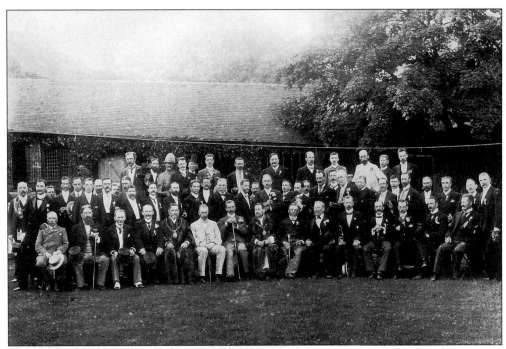

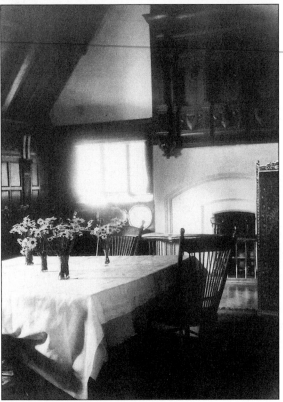

The eighth Earl De La Warr's reception in the Manor House grounds after his return from the Boer War, 25 July 1900. The Earl is sitting in the middle of the front row and has both of his hands on a walking stick. He returned from the war after being injured rescuing a wounded soldier. Daniel Mayer is to the right of the Earl.

The dining room of the Manor House, 1912. A rare interior view of the Manor House taken when it was owned by the Du Mont family.

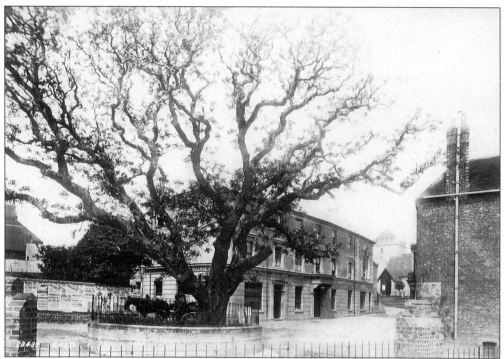

The walnut tree with the Bell Hotel and St Peter's church behind, 1891. The tree was cut down in around 1906 and the stump removed in 1921. In 1906 Lord Brassey had a gavel made from the wood and presented it to the town together with the gold mayoral chain.

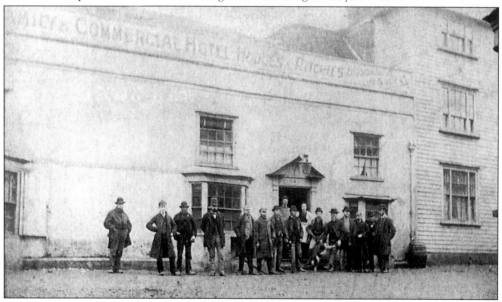

The locals have all turned out for this photograph of the Bell Hotel in April 1879. The building is probably seventeenth century and the first reference to the Bell was in 1751. The Bell's assembly room was used for various local meetings as well as serving as a theatre. Before the development of the new town, the Bell along with St Peter's church and the Manor House were the centres of village life.

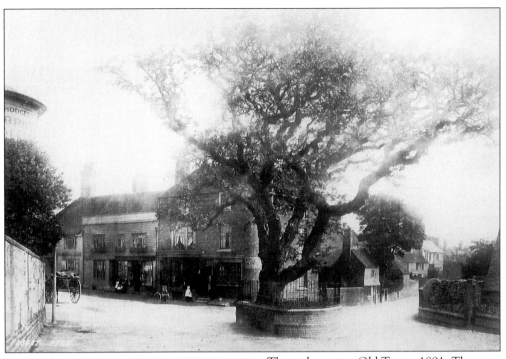

The walnut tree, Old Town, 1891. The tree was once in the Manor House grounds but a road was cut across the corner of the grounds leaving the tree which was enclosed by a low wall.

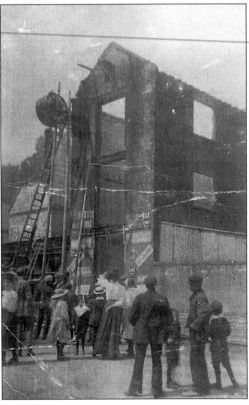

A fire at Cave Austin & Company's warehouse, Bexhill Old Town, 20 June 1908. The building was gutted and the workings of the Jubilee Clock destroyed. The warehouse was rebuilt and a replica of the clock's mechanism installed.

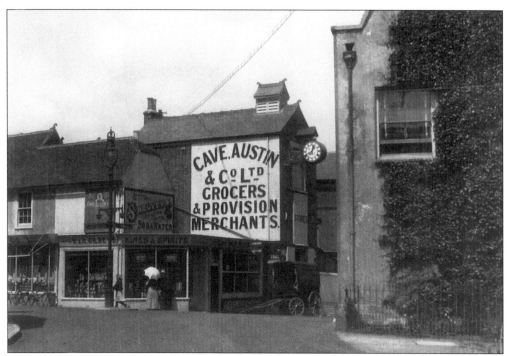

Bexhill Old Town in 1912. Cave Austin & Company's warehouse supports the Jubilee Clock which was installed in 1887 to mark Queen Victoria's Golden Jubilee. In the foreground is the side of South Lodge.

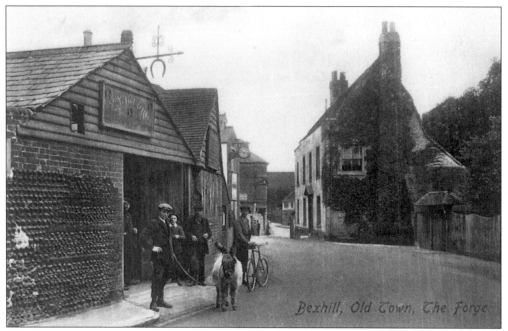

Old Town Forge and South Lodge, *c.* 1900. The forge was demolished in 1947 and South Lodge in 1967. South Lodge was part of the Manor House complex and next to it is one of the gates into the site.

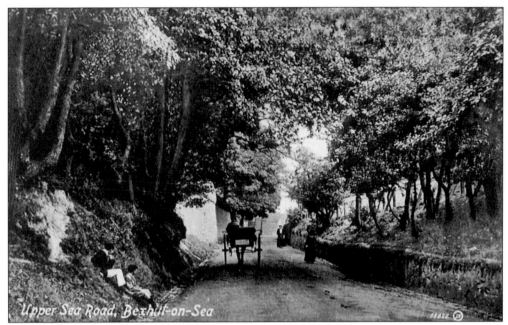

Upper Sea Road, *c.* 1900. This road, once known as Sea Lane, linked the inland settlement of Bexhill with the coast and later linked the Old Town with the Earl's new resort of Bexhill-on-Sea.

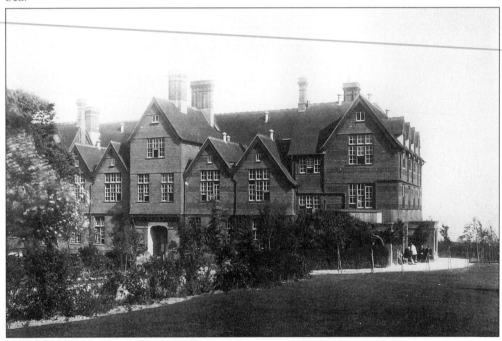

The Metropolitan Convalescent Institution, *c.* 1890. The home was opened in 1881 and started the trend for convalescent and residential homes in Bexhill. In 1905 another institution was built in Cooden which housed the men while the women remained in the Old Town. Bexhill was believed to be an ideal place for the sick to recuperate because of the health-giving properties of the air and water.

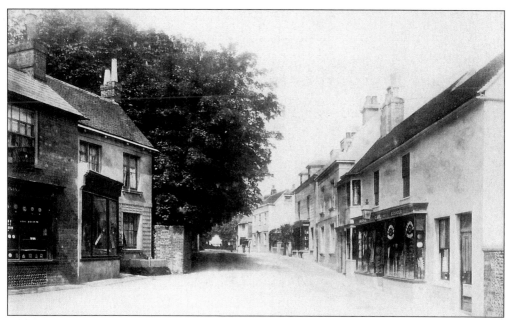

Old Town High Street, *c.* 1891. The shop on the left is a clockmaker's and the one on the right a grocer's.

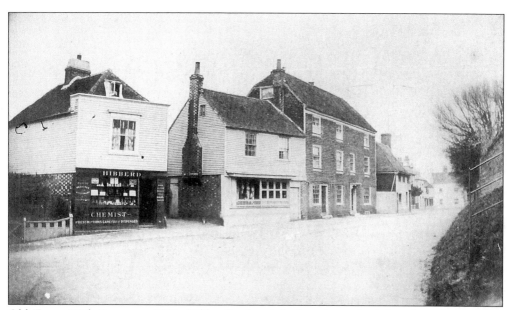

Old Town High Street, *c.* 1894. Hibberd's chemist's shop is on the left and in the centre is Pocock's butcher's shop. Pocock's was the oldest shop in Bexhill: it started in 1801 and closed in 1998.

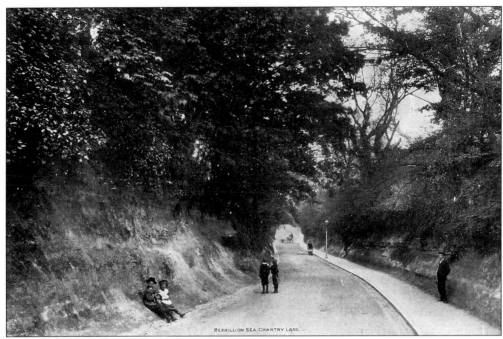

Chantry Lane, c. 1890. The depth of the sunken lane suggests that it is very ancient. It links the Old Town to Holliers Hill and Sidley.

Belle Hill Wesleyan Methodist Chapel, c. 1880. This was built in 1825 on land that had been part of the King's German Legion barracks and closed in 1938.

Cockett's grocery, Belle Hill, c. 1900. The man in the hat is Mr Budden. The shop later moved to London Road.

Belle Hill (originally called Belly Hill) at the junction with London Road, c. 1885. The building with the awning outside is Pilbeam's butcher's shop and the area was known as Pilbeams Corner. Samuel Scrivens, who in the 1870s was the largest local landowner after Earl De La Warr, lived at Millfield on Belle Hill. Mr Scrivens owned the farmland between Belle Hill and the old railway station and when he sold it in the early 1880s the development of London Road began and created Bexhill-on-Sea's first shopping centre.

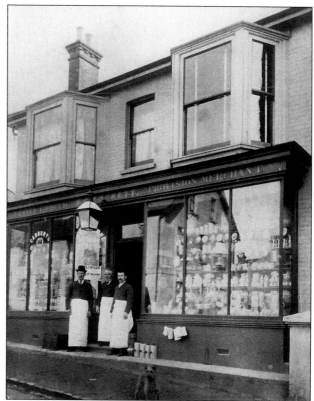

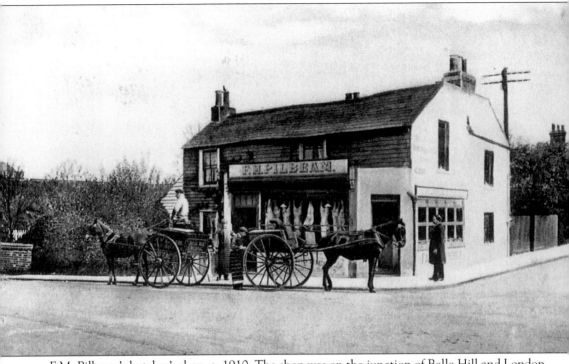

F.M. Pilbeam's butcher's shop, *c.* 1910. The shop was on the junction of Belle Hill and London Road or 'Pilbeams Corner' as it was known.

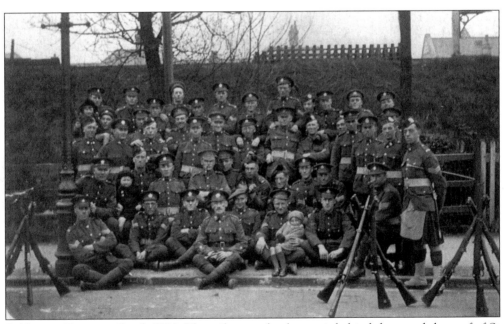

Soldiers in Terminus Road, 1914. The railway embankment is behind them and the roof of St Andrew's church (built in 1899) in Wickham Avenue is on the right.

Three
Bexhill-on-Sea: The New Town

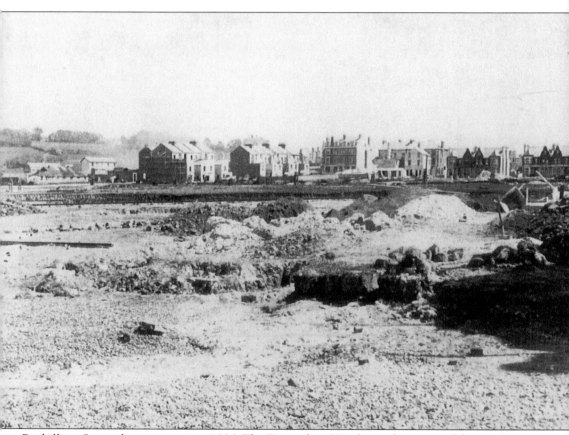

Bexhill-on-Sea under construction, 1886. The Devonshire Hotel is in the centre of the picture, which was taken from the site of the Coastguard Station, now occupied by the De La Warr pavilion.

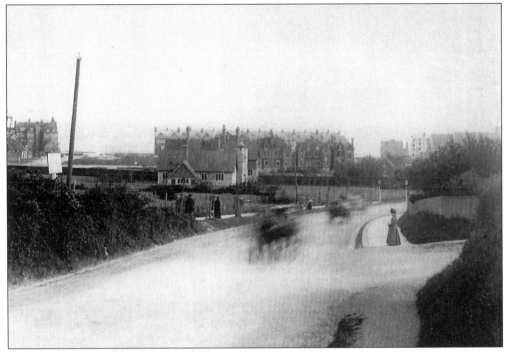

Sea Road near the junction with Magdalen Road, *c.* 1896. On the left is the original Catholic church of St Mary Magdalene which opened in 1891.

The first St Mary Magdalene's church, 1903. A mission opened in 1891 and the clergy house and church school were built in 1893. The foundation stone of the present church of St Mary Magdalene was laid in 1906 and it opened in 1907. The consecration took place in 1913.

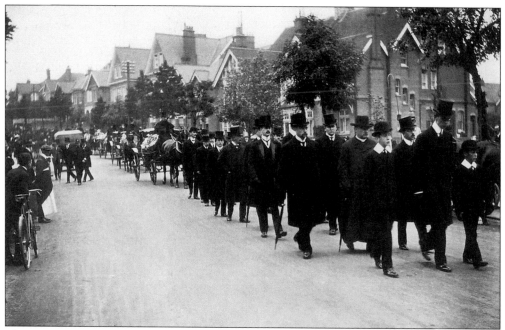

The funeral cortège of Mr August Neven Du Mont 1909. The procession is passing down Sea Road, from the Manor House to St Mary Magdalene's church. Mr Du Mont leased the Manor House in 1903 and died aged forty-two in 1909. The family, who were German, left just before the start of the First World War. The Du Monts converted the Manor House barn into a ballroom, which is now the Manor Barn.

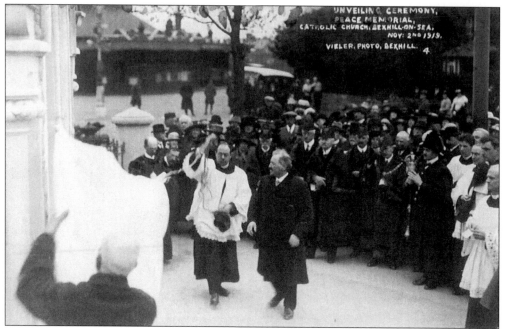

Unveiling of the War Memorial outside St Mary Magdalene's church, 2 November 1919. This was the town's first memorial to the First World War and was designed by G.H. Gray, the Mayor. The railway station is in the background.

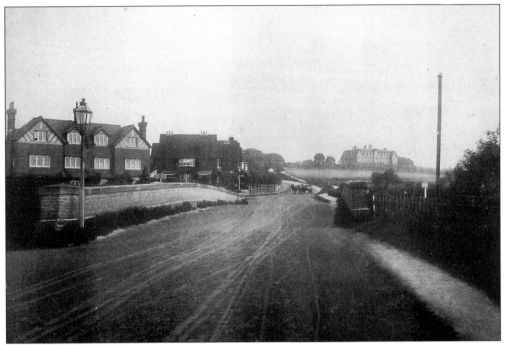

Sea Road by the railway bridge, looking up towards the Old Town, 1891. The Metropolitan Convalescent Institute dominates the skyline.

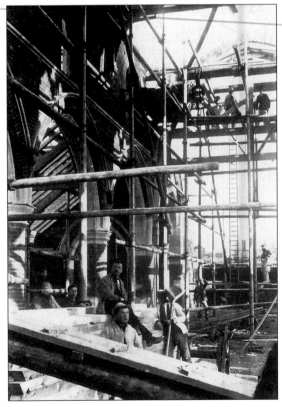

The construction of St Barnabas' church, Sea Road, 1890. The church was built to serve the new resort and was opened in 1891. The south aisle was added in 1909.

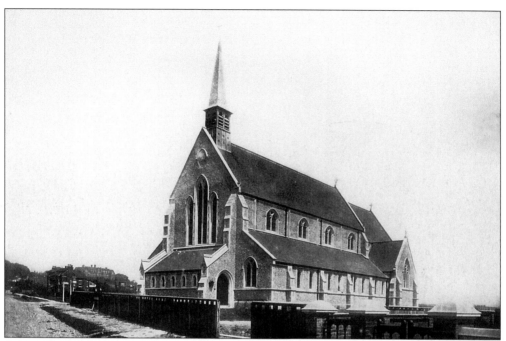

St Barnabas' church, Sea Road, in 1891, just after it was completed. The church was designed by Sir Arthur Blomfield. The Convalescent Home is in the background.

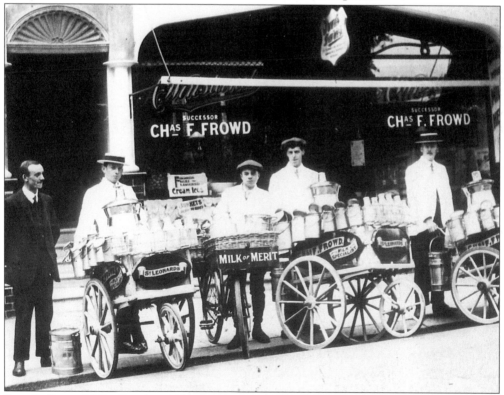

Frowd's Dairy, 32 Sea Road, c. 1920. On the left is the manager, Mr Frederick Hope.

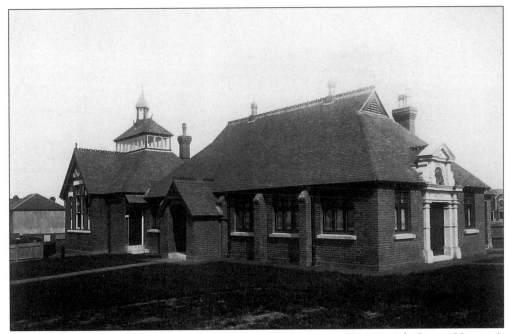

The Bexhill Institute, Station Road, c. 1890. It was built in 1887 to mark Queen Victoria's Golden Jubilee and contained a reading room, smoking room, committee room, card room and bar parlour. A billiard room was added in 1890. It is now the Youth Centre.

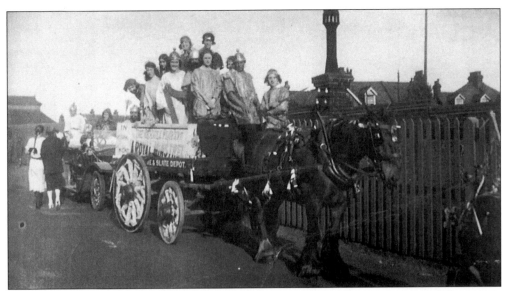

The Bexhill Players' float entitled 'A Royal Minstrel' in Station Road, on Carnival Day, 1923. To the left is the roof of Bexhill Central station.

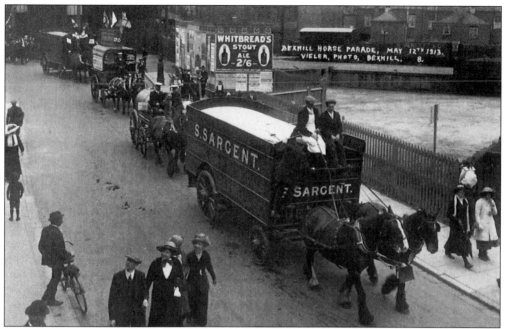

Bexhill Horse Parade in Station Road, 12 May 1913. The wagon belonged to S. Sargent who owned a furniture removal firm that stood opposite the Town Hall. The procession is passing the railway goods yard, which was the site of the first railway station in 1846 and is now Sainsbury's car park.

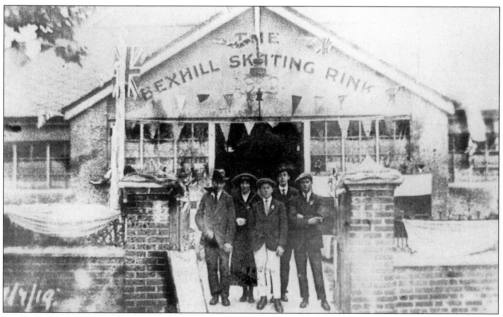

Bexhill skating rink, Buckhurst Road, Peace Day, July 1919. The rink closed during the 1920s and became a garage. In 1937 the Ritz cinema opened on the site. The Ritz was the largest and most lavish of Bexhill's cinemas. It closed in 1961 and the telephone exchange now stands on the site.

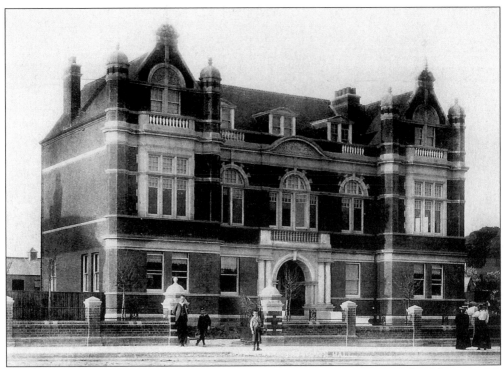

Bexhill Town Hall, *c.* 1897. The Town Hall was built in 1894, was opened the following year with great ceremony by the Lord Mayor of London and was extended in 1907.

The Town Hall, *c.* 1900. The London & County Bank, on the right, was opened in 1898, the same year as the memorial to Lieutenant-Colonel Henry Lane, the first chairman of the Urban Council, who died in 1895.

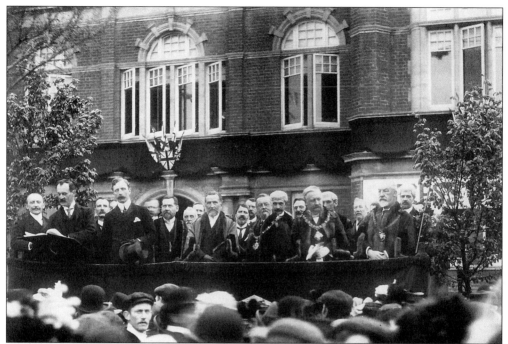

The reading of Bexhill's Charter of Incorporation, Town Hall Square, 21 May 1902. Mr E. Sholto Douglas, the first Town Clerk, is reading the charter; to the right of him is the eighth Earl De La Warr and next to him is Daniel Mayer. Mayer lived at Collington Manor, was one of the Earl's staunchest supporters and was mayor four times. The charter making Bexhill a borough was the first to be granted by Edward VII and the first to be delivered by motor car.

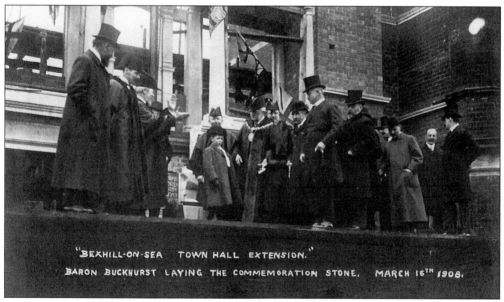

Laying of the commemorative stone for the Town Hall extension by the mayor, Earl Brassey, and his grandson, Baron Buckhurst, the future ninth Earl De La Warr, on 16 March 1908.

39

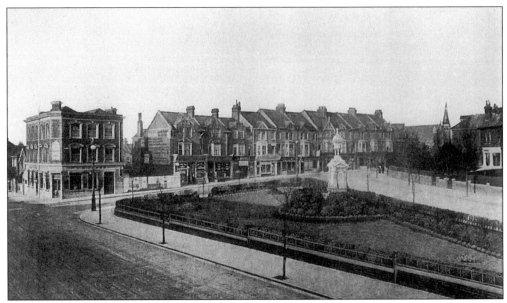

Town Hall Square (Buckhurst Place), *c*. 1909. The Castle Hotel, which was built in 1886, is on the left and the gap next to it was filled by the Bijou Cinema in 1910 which closed in 1954.

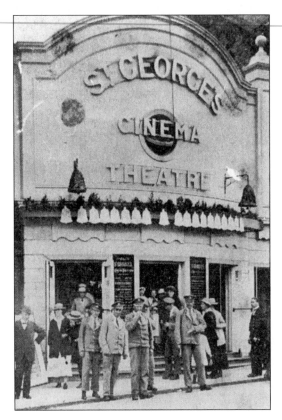

St George's cinema, Town Hall Square, *c*. 1915. Built in 1910 as the Bijou Theatre, it was Bexhill's first purpose-built cinema. During the First World War it changed its name to St George's cinema and entertained wounded soldiers, some of whom are shown in this photograph. The cinema closed suddenly in 1954 and the building remained for many years before being demolished. The site is now the beer garden of the Castle.

The first house to be built in Lower
Station Road (now London Road), 1890.

Brighton Supply Association wine
merchants at 23 Lower Station Road,
c. 1898. The road was renamed London
Road around 1924. The manager, Mr E.
Davy, is in the doorway.

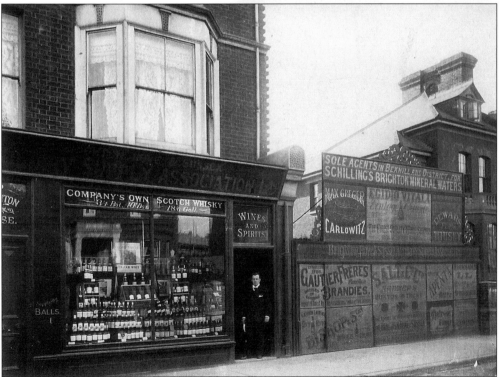

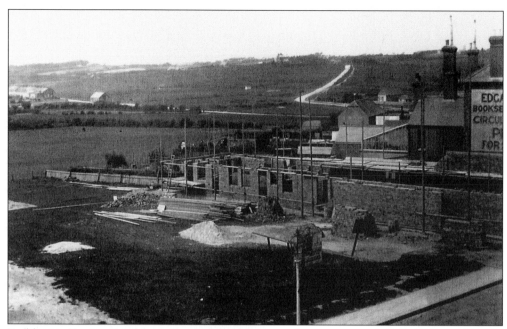

Building in Station Road (now London Road) near to the junction with Belle Hill, *c.* 1890. At the top left is Beacons Field Terrace and the Down Mission church on the Little Common Road and at the top of the picture is Down Road cutting across Bexhill Down.

Mineral spring, 'Spa Road' (London Road), *c.* 1890. The chalybeate (mineral-rich) spring was at the junction of London Road and St George's Road. The mineral springs were another aspect that contributed to Bexhill's reputation as a health-giving resort.

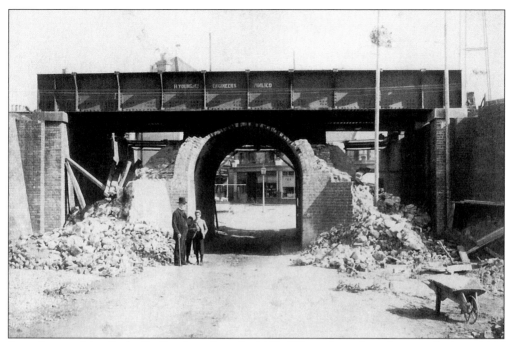

Demolition of the Sackville Road cattle arch, 1892. When the railway line was built in 1846 this was one of three cattle arches, the others being at Collington and Cooden, that linked farms with their fields south of the line. The arch was widened into a bridge in 1892 to improve access to the new resort. The cast iron bridge was made at the Pimlico foundry of Henry Young who lived at Cooden Mount and who also cast the bronze sphinxes that support Cleopatra's Needle in London. The bridge was replaced with a more modern design in March 1978.

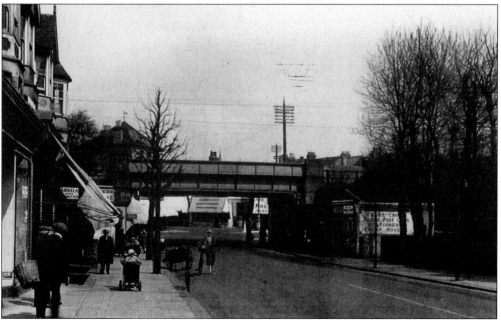

Sackville Road, looking towards Sackville Arch, c. 1920. In 1913 the bridge proved to be to low for Mr Pulham's new double-decker bus – a problem that still occurs!

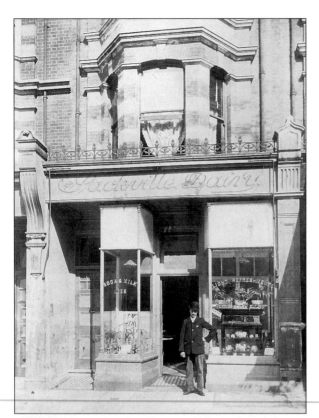

The Sackville Dairy, 23 Sackville Road, c. 1900. As can be seen from the notices in the window, the dairy served drinks and ice creams.

The opening of the Picture Playhouse in Western Road, 1921. The building to the right is the Cinema de Luxe which opened in 1913 and closed in 1921. Both cinemas were owned by the same company. The Playhouse became the Curzon in 1974 and is the town's only surviving cinema.

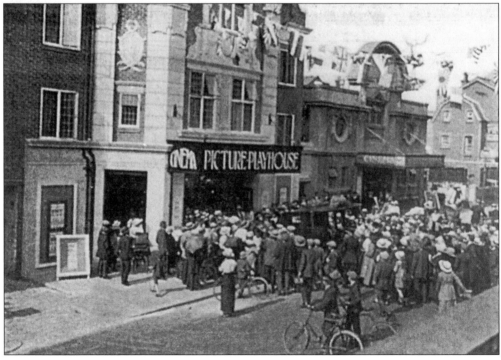

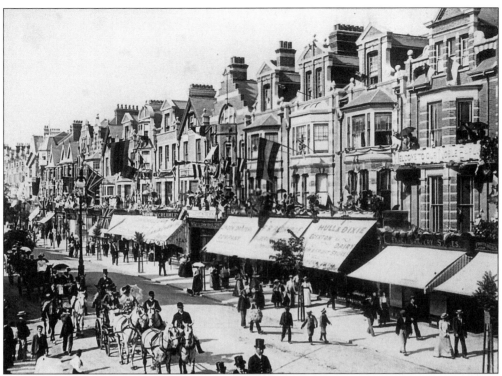

Devonshire Road, July 1900. The procession was to welcome the eighth Earl De La Warr on his return after being wounded in the Boer War.

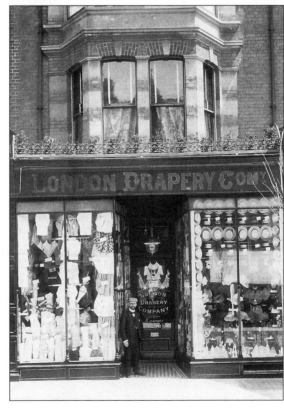

The London Drapery Company, Devonshire Road, *c.* 1900. The manager, Mr E. Redman, is in the doorway.

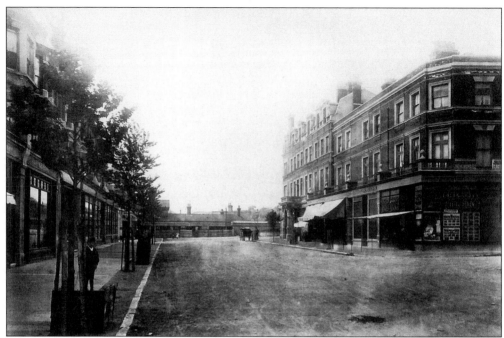

Devonshire Road, 1891. The railway station is at the top of Devonshire Square (then Station Square) and a private library stands on the corner of St Leonard's Road.

The Devonshire Hotel, Devonshire Square, 1891. The hotel opened in 1886 and was built by John Webb who was also its first lessee. Note the shops that stand on the site now occupied by the post office which opened in 1931.

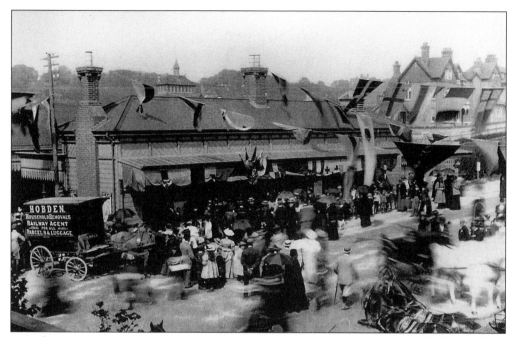

Crowds wait outside the Devonshire Road railway station for the eighth Earl De La Warr's return from the Boer War, July 1900. The station opened here in 1891 but moved to the present site in 1902.

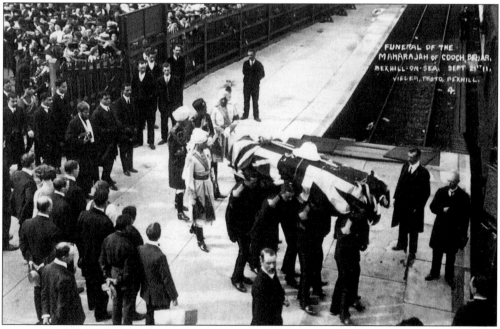

Funeral of the Maharajah of Cooch Behar, Nripendra Narayan Bhup Bahadur, 21 September 1911. The Maharajah's body is about to be put on a train to London. The funeral procession has entered the station via Devonshire Square. The Maharajah came to Bexhill to try to regain his health but did not recover from his illness. His stay led to many local myths about the Maharajah building houses on the seafront.

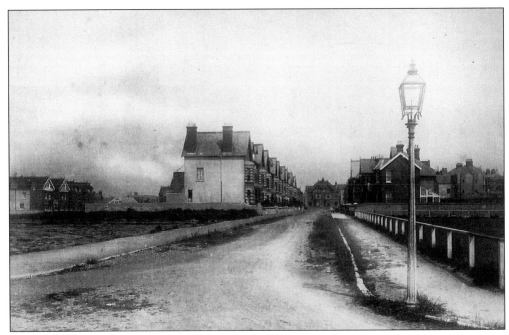

Albert Road from the Marina, *c.* 1892 – note the unmade roads.

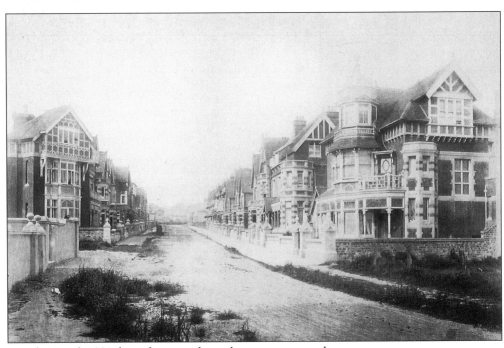

Eversley Road, 1891: here the unmade road is sprouting weeds.

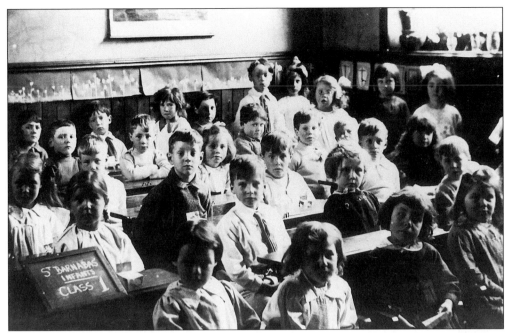

St Barnabas' school, infant class I, c. 1919. The late Phyllis Burl, who was a respected local historian, stands below the window. In 1893 St Barnabas' school opened as an infants' school for the parish in the building that became Bexhill Public Library in 1951. St Barnabas' boys' school opened in Reginald Road in 1898.

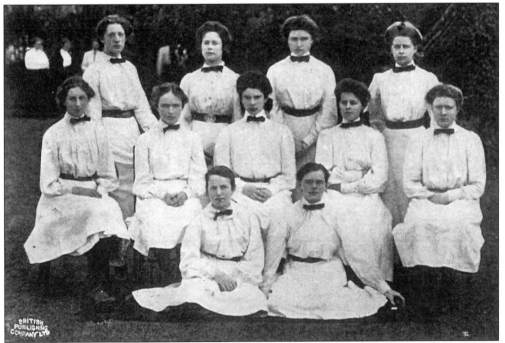

The Beehive school's cricket eleven, 1907. The school was founded at Windsor in 1876 but moved to Bexhill in 1900. At first the school was in Dorset Road but moved to Broadoak Manor after the Second World War.

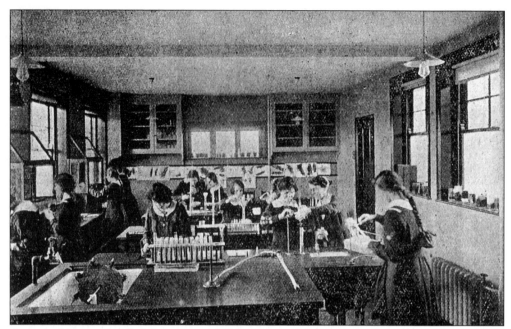

Ancaster House school's laboratory, c. 1923. Ancaster House opened as a boys' school on the Hastings Road in 1887 and in 1906 it became a girls' school. The most famous headmistress was Miss Burrows, daughter of its founder, who was an alderman of the borough and received the freedom of the borough in 1958.

Egerton Park, c. 1890, looking south from the Wickham Avenue entrance. The low building in the distance is the swimming bath that was built in 1889.

Egerton Park, *c.* 1891. The park was laid out in 1888 by John Webb and purchased from him by the Urban Council in 1901. During the excavation of the lakes dinosaur bones and the remains of an ancient boat were uncovered.

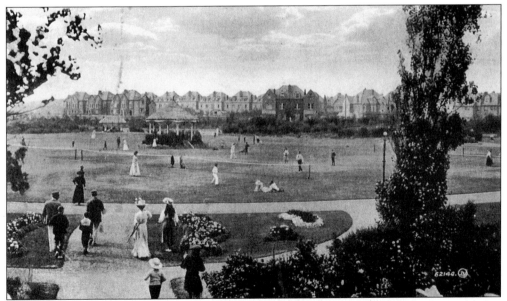

Egerton Park, *c.* 1905. The park was intended as a means of draining the surrounding land as well as providing leisure facilities for residents and visitors. The park was extended to its present size in 1906.

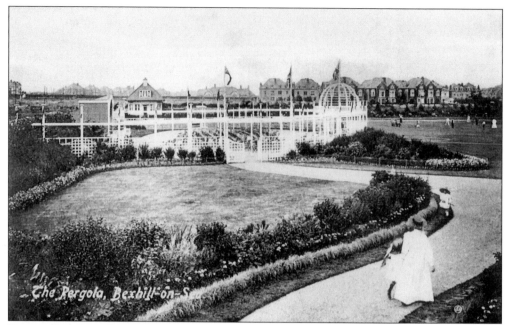

Egerton Park Pergola, c. 1910. Built in 1906, it was enclosed in 1933 to form the Egerton Park Theatre and indoor bowling centre.

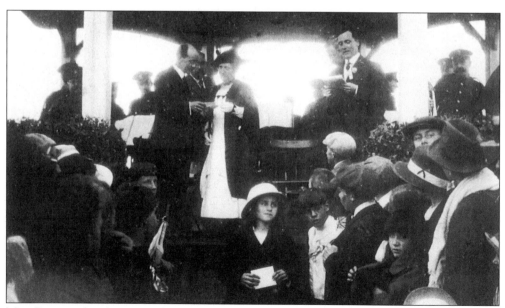

Miss Burrows, headmistress of Ancaster House school, handing out certificates at the Peace Thanksgiving Service at the Egerton Park Pergola, 1919.

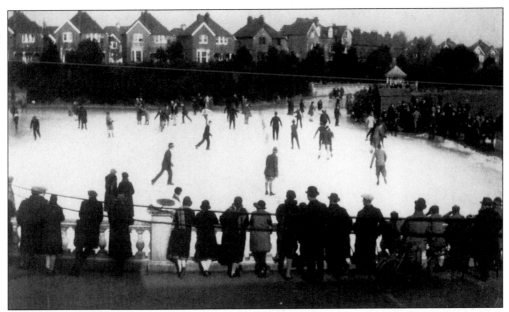

Skating on the boating lake in Egerton Park, 1929. The lake is now mostly filled with sea water and so rarely freezes deeply enough to skate on.

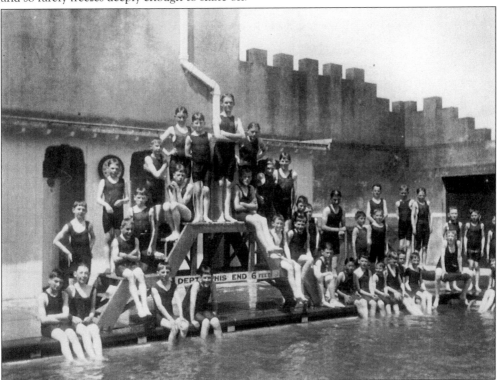

Boys on the diving platform of the Egerton Park swimming bath, *c*. 1910. The building in the background was the Park Shelter Hall and in 1914 it became the Museum. The first swimming bath on the site was built by John Webb in 1889. It was relined several times and was finally closed in the early 1980s.

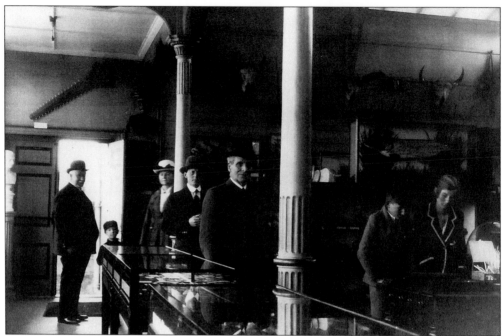

Bexhill Museum, *c*. 1920. Between the pillars is the Revd Thompson, the first curator when the Museum was founded in 1914, and behind him is a young Henry Sargent who became the second curator in 1923 and remained in post until his death in 1980. The photograph was taken by George Herbert Gray, who was a prominent local architect and agent for the De La Warr Estate.

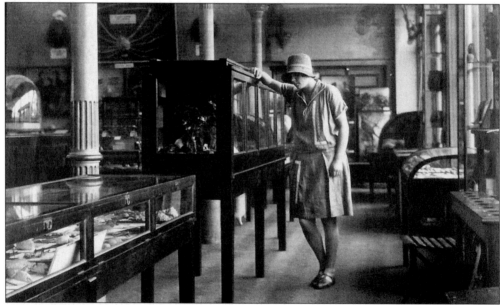

Bexhill Museum, *c*. 1925. A small group of enthusiasts met in 1912 with the intention of setting up a museum for the town. Foremost among them were the Revd J.C. Thompson and Kate Marsden FRGS. The use of the Egerton Park shelter hall was granted by the Corporation and the Museum opened to the public in 1914.

Four
The Seafront

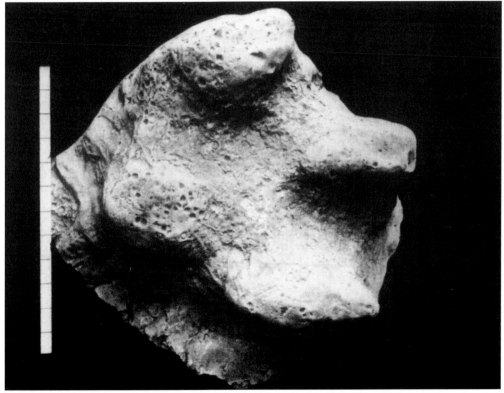

Fossil cast of a dinosaur's footprint from Bexhill beach, found by Revd Thompson in around 1920. The dinosaur was *Iguanodon*, a large herbivore that lived 130 million years ago.

Wreck of the *Amsterdam*, Bulverhythe. The Dutch East Indiaman ran aground at Bulverhythe in 1749. During their stay at Bexhill the King's German Legion attempted to dig into the wreck but the ship is still well preserved below the sands.

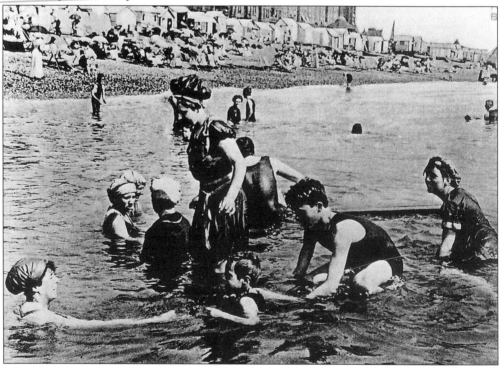

Mixed bathing off De La Warr Parade, *c.* 1905. Bexhill became famous for being the first British resort to offer mixed bathing, in 1901.

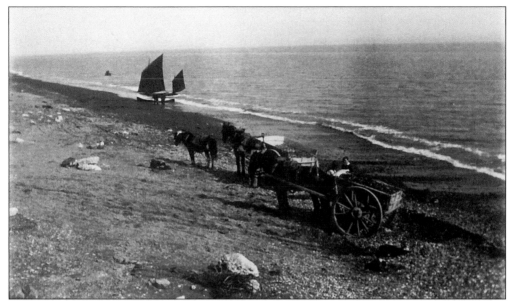

Collecting shingle from the beach for building, *c*. 1890. The beach was a useful resource for the town and before the railway line was put through in 1846 coal used to be brought to the Old Town by the coal ship *Phoenix*. It was unloaded opposite the end of Sea Lane (now Sea Road) and taken up to the village by cart.

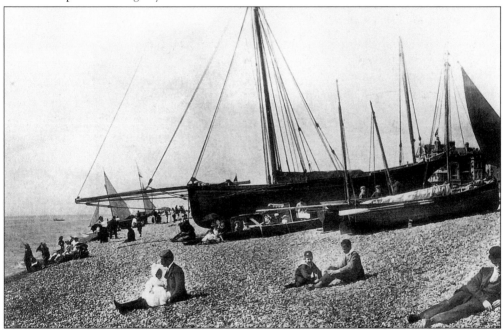

The beach, *c*. 1896. Before Bexhill-on-Sea was developed, the village was an inland settlement and did not support a fishing industry. After the seventh and eighth Earls De La Warr built the new resort, the beach became readily accessible for those who could afford the luxury of leisure time. Most of the boats in this picture would have been used for pleasure trips, one of the delights that the new resort offered. The large vessel is the *Skylark* which was owned by Mr James Gold who constructed the buildings between Sea Road and Brassey Road.

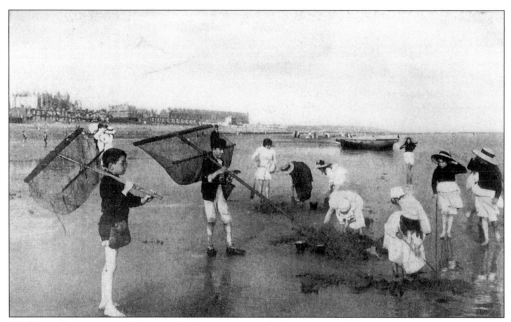

Children shrimping and digging for lugworms on the beach, *c.* 1900.

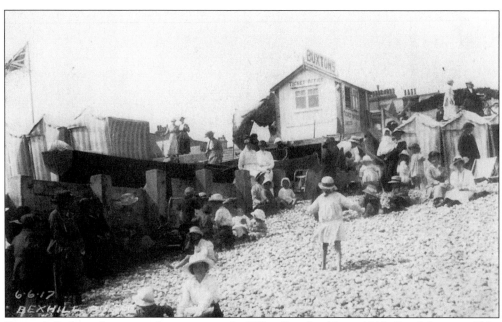

Buxton's Bathing Station at the eastern end of West Parade, 6 June 1917. Beach huts could be hired from the ticket office in the centre of the photograph.

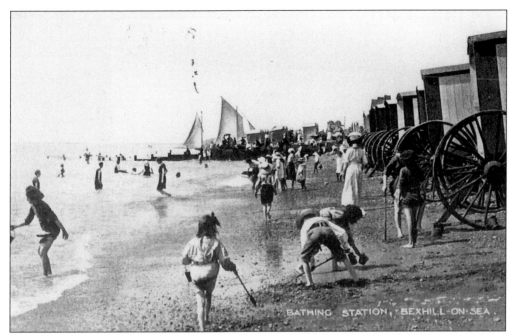

The Bathing Station below West Parade, *c.* 1900. Bathing machines could be winched down the beach and into the sea to protect the modesty of female bathers! After 1901 Bexhill became the first resort to permit mixed bathing and so the use of bathing machines declined.

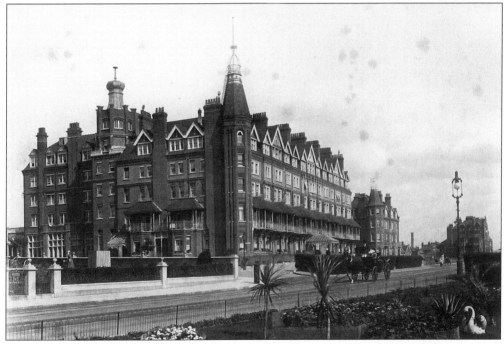

The Sackville Hotel, *c.* 1895. The building was originally a row of four houses that were joined to form a hotel which opened for business in 1890. Viscount and Lady Cantelupe lived there while the Manor House was being refurbished for them. The frontage was extended in 1920 and it was converted into flats in 1963.

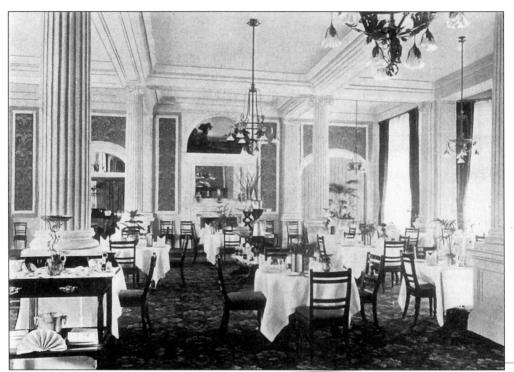

The Sackville Hotel's dining room, *c.* 1901. The Sackville was the largest and most prestigious of Bexhill's hotels and Earl De La Warr intended it to be the centre of his new resort.

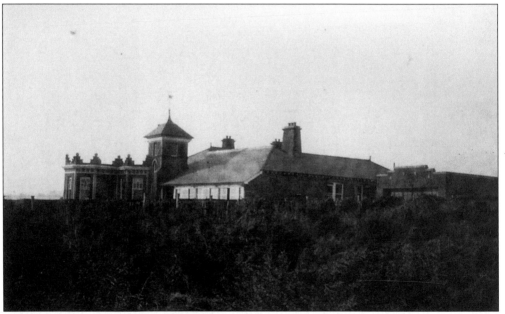

Sackville Lodge, Galley Hill, *c.* 1905. The house was built at the top of Galley Hill in 1903 and it is believed that Lady De La Warr lived there after she divorced the eighth Earl for adultery in 1902.

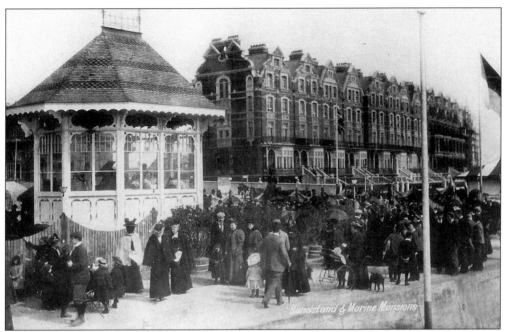

A busy Victorian scene on De La Warr Parade, *c.* 1896. In the bandstand Herr Wurm's White Viennese Band are playing. During the summer season the seafront would have been a noisy place.

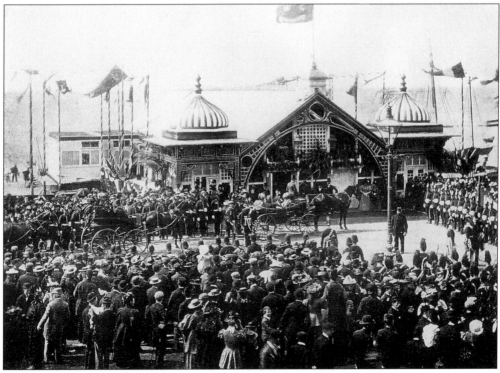

The opening of the Kursaal by the Duchess of Teck, Whitsun 1896. The building was demolished in 1936 and the present Sailing Club's headquarters were built on the site in 1965.

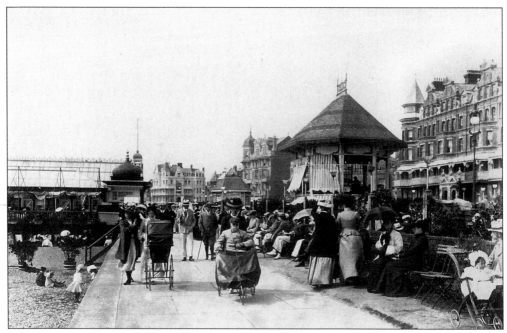

De La Warr Parade, *c.* 1905. On the left is the Kursaal which was built by the eighth Earl De La Warr in 1896 as a high class entertainment pavilion. In the background are Wilton Court (opened 1900) and the Marine Mansions Hotel (built 1895 and demolished 1954).

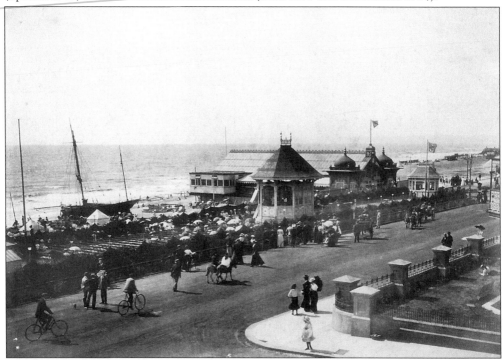

The Kursaal and bandstand, *c.* 1898. Inside the Kursaal were a theatre, reading rooms and tea lounge. It was intended as the first stage of a pier but this was never implemented. The *Skylark* is pulled up on the beach below the Kursaal gardens.

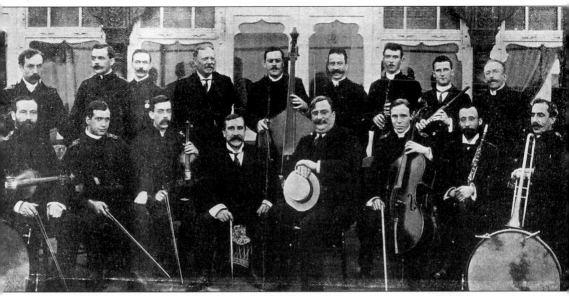

Mr Glover and his band at the Kursaal, April 1908. Jimmy Glover was appointed as manager of the Kursaal in 1900 and stayed in post until 1905 shortly before becoming mayor in 1906-07 and deputy mayor to Lord Brassey in 1907-08. He resumed his position at the Kursaal in 1908 and remained there until around 1913.

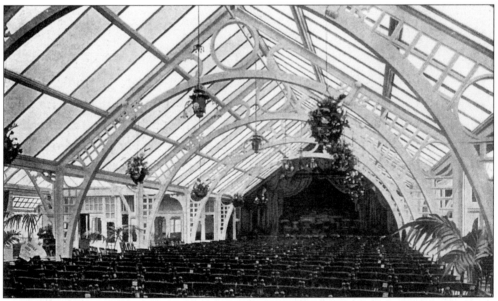

Kursaal Theatre, c. 1901. Many of the finest acts in the country played on the Kursaal's stage. From 1900 it was managed by Jimmy Glover who was also the Musical Director at Drury Lane and arranged for many artistes to come down to Bexhill from London. By 1908 the popularity of the Kursaal declined and the eighth Earl De La Warr sold it. It was finally demolished in 1936.

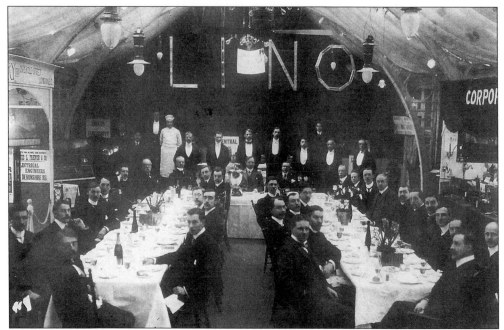

The British Electrical Exhibition at the Kursaal in 1905. The eighth Earl De La Warr sits at the head of the table. Viscount Cantelupe (the future eighth Earl) and Mr Robert Kersey applied for a licence to supply electricity to Bexhill in 1895 but were blocked by the Urban Council, of which Viscount Cantelupe himself was chairman – he received compensation instead! The first electric lights in Bexhill were switched on in April 1900.

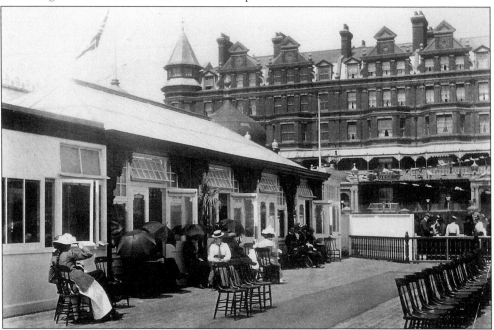

The deck of the Kursaal, c. 1900. In 1899 the eastern side of the Kursaal was extended and a tea lounge was built; beyond this was an open deck which allowed people to sit in the sunshine. Hats and parasols helped to reduce the risk of an unsightly tan.

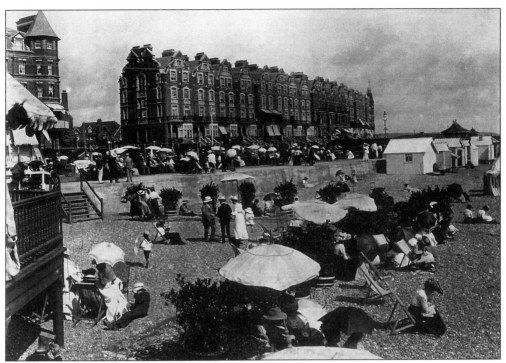

The Kursaal garden, *c.* 1905. Marine Mansions are in the background and to the left is the edge of the Kursaal's deck. The 'garden' consisted of chairs and potted plants arranged on the shingle. The Kursaal's name was changed to the Pavilion during the First World War and it was demolished in 1936. The site is now occupied by the Sailing Club.

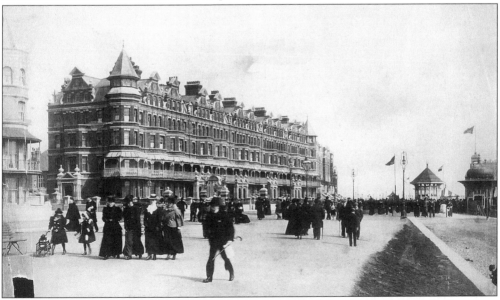

De La Warr Parade, *c.* 1900. The De La Warr Gates marked the entrance to the Earl's private road. These were built in 1895 when the Urban Council refused to buy De La Warr Parade from him, and they were demolished in 1913 when the Bexhill Corporation finally bought the land. The buildings in the background were built by Mr Gold in about 1890.

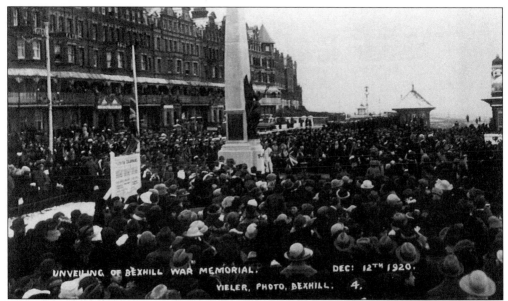

Unveiling of the War Memorial by Brigadier-General H. O'Donnell, 12 December 1920.

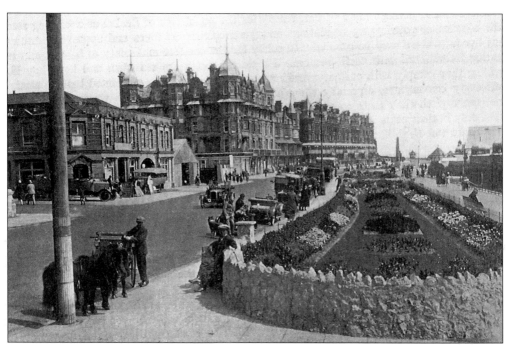

The Marina, c. 1927. To the left of the picture is Marina Garage which arranged coach tours around the district. On the right are the Cairo and the Kursaal (then known as the Pavilion) which had been refurbished and had gained a new roof.

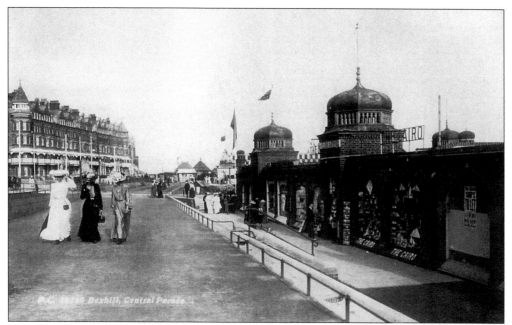

The Cairo, Marina, *c.* 1906. The eastern end of Marina Arcade contained the Cairo Toy and Fancy Repository which provided a library, gift shop and tea rooms. Marina Arcade was built in 1905 and was originally intended to have a swimming pool or Turkish bath in the middle. Its oriental architecture matched that of the Kursaal and led to the popular local myth that it was built by the Maharajah of Cooch Behar, which is untrue.

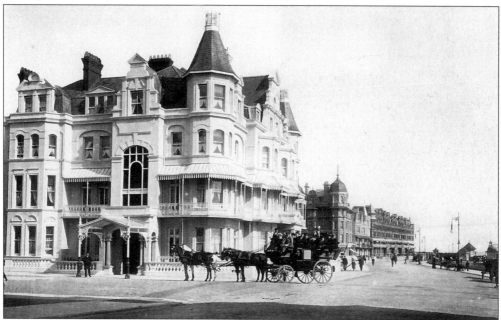

A coach turning into Devonshire Road, *c.* 1896. The building behind is the Marine Mansions Hotel which opened in 1895. In 1903 it became a holiday home for drapers and was renamed Roberts Marine Mansions. The building was severely damaged during the Second World War and was demolished in 1954.

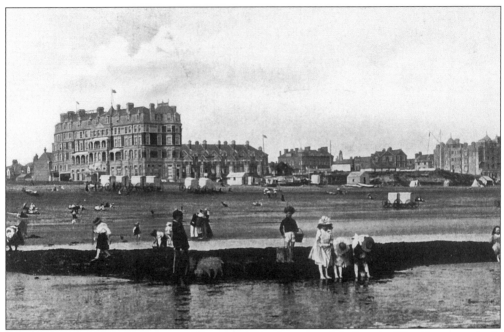

The beach below the Hotel Metropole, *c.* 1901. To the right of the hotel is The Horn on which stood the coastguard station; the Colonnade was built on this site in 1911. Note the bathing machines at the top of the beach.

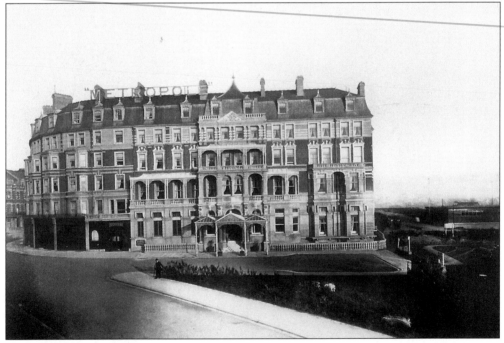

The Metropole Hotel, *c.* 1900. The Hotel stood on the site that is now the lawn and putting green on the west side of the De La Warr Pavilion. Construction of the Metropole began in 1897 and it was opened in 1900. A fire was caused by troops billeted there in 1940 and bomb damage in 1941 left the hotel derelict. It was demolished in 1955.

The Lord Mayor of London, Sir W. Vaughan Morgan, leaving the Metropole Hotel to open the Egerton Park extension in 1906. The extension added four acres to the park, bringing it up to Brockley Road.

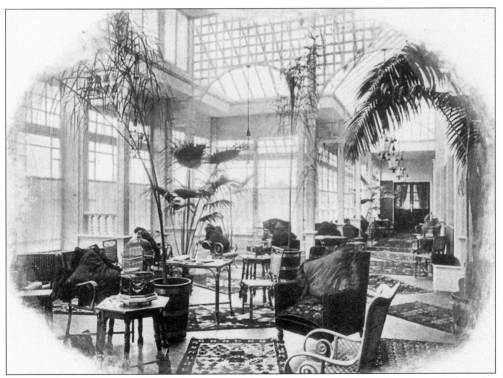

The Hotel Metropole's winter garden, *c.* 1901. Although there were many hotels in Bexhill, the quality of the Metropole made it the Sackville's main rival.

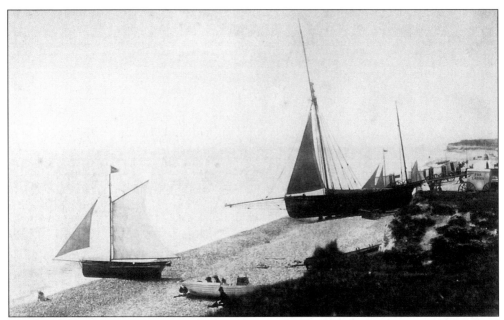

The beach by The Horn, *c.* 1894. The large boat is the *Skylark* which was owned by Mr Gold and gave pleasure trips for visitors to the resort.

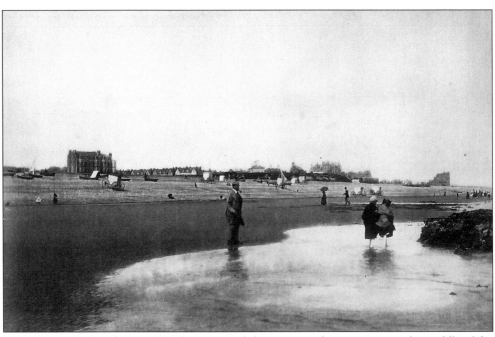

Bexhill from the beach, *c.* 1895. The Horn and the coastguard cottages are in the middle of the photograph. This site is now occupied by the Colonnade and De La Warr Pavilion.

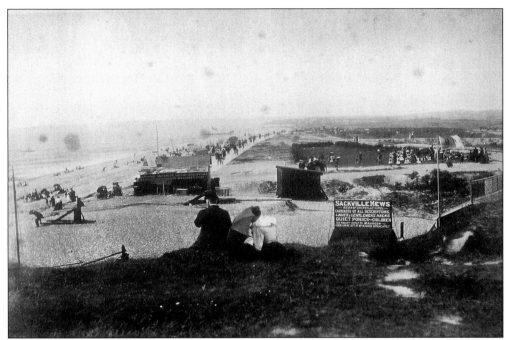

West Parade from The Horn, c. 1894. An undeveloped West Parade can be seen going off into the distance and even without sophisticated amenities the seafront appears busy. Bexhill Rowing Club's flag is flying from their boathouse on the right.

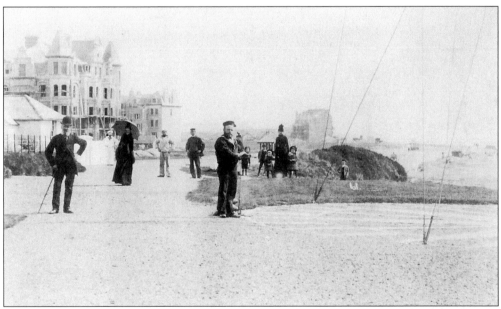

The coastguard station, 1894. This site is now occupied by the De La Warr Pavilion. The coastguard station on The Horn and later the Kursaal were the two main sites for social activity on the seafront. The Marine Mansions Hotel is under construction in the background.

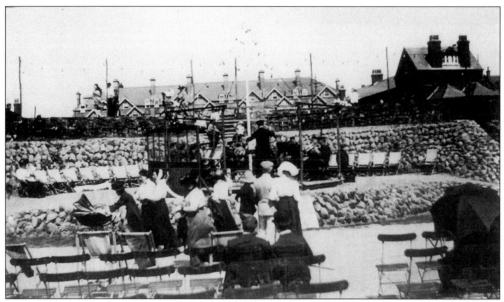

The bandstand, Central Parade, 1910. The Horn was developed and became Central Parade in 1910. The coastguard cottages are in the background. Martello Tower No. 46 once stood near here but was demolished in 1870.

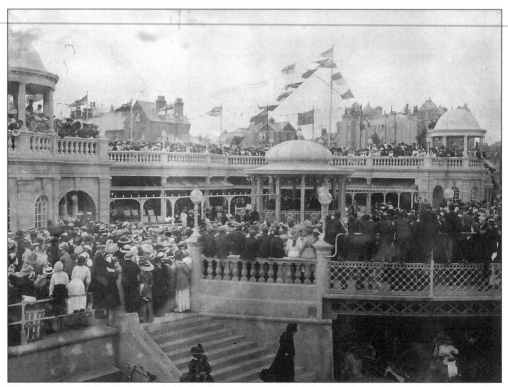

The opening of the Colonnade by Earl Brassey in 1911. The bandstand and the walkway that projected over the beach have since been destroyed. In the background are the coastguard cottages and Marina Court.

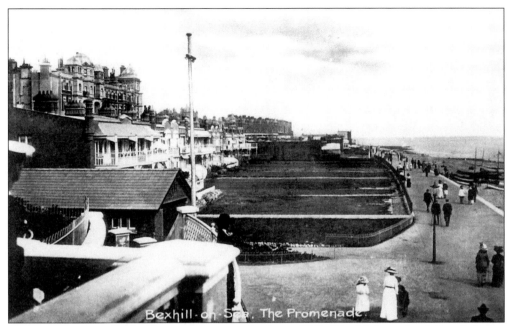

Channel View, c. 1912. Channel View was built in 1907. The Maharajah of Cooch Behar stayed in and died at the westernmost house in 1911. The photograph was taken from the steps of the Colonnade. The Rowing Club's boathouse is in the foreground and Marina Court can be seen behind Channel View.

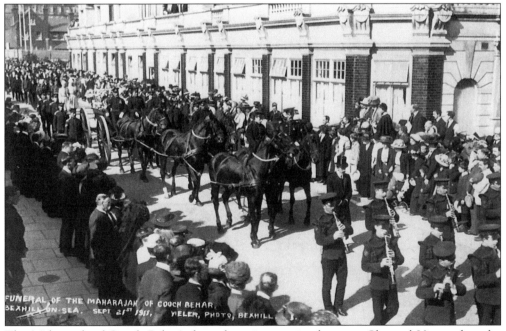

The Maharajah of Cooch Behar's funeral cortège passing between Channel View, where he died, and Marina Court, 21 September 1911.

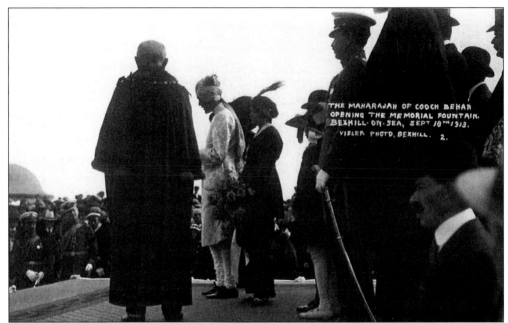

Opening of the Memorial Fountain to the Maharajah of Cooch Behar by his second son, Maharajah Kumar Jitendra, 18 September 1913. The fountain stood where the De La Warr Pavilion is now; one of the domes of the Colonnade can just be seen. The fountain was moved to Egerton Park in 1934 but was demolished in 1963.

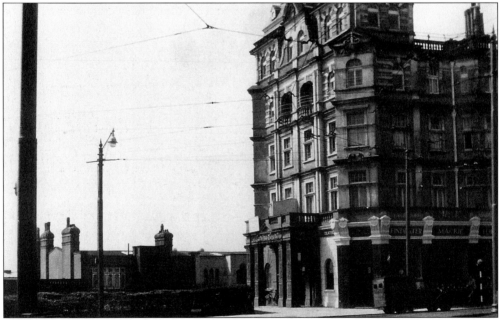

Marina Court from the junction of Sea Road and Marina, May 1951. In 1895 the land was known as the 'Triangular Plot' and belonged to Earl De La Warr. When the Urban Council failed to maintain the plot the Earl sold it to Mr Gold who developed it. Marina Court was a block of flats with shops at street level. It opened in 1901 and was demolished to extend the De La Warr Pavilion's car park in 1970.

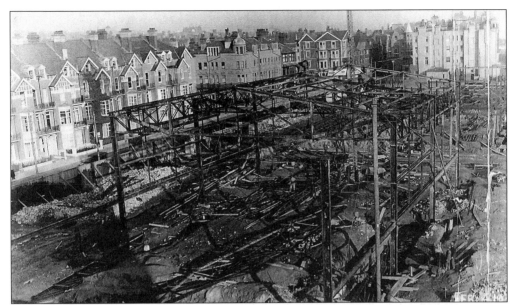

Construction of the De La Warr Pavilion, February 1935. Marina Court can be seen to the far right. The Pavilion was built on the site of the old coastguard station and cost £80,000. It was the first public building in Britain to be built in the 'International Modernist' style using a welded steel frame.

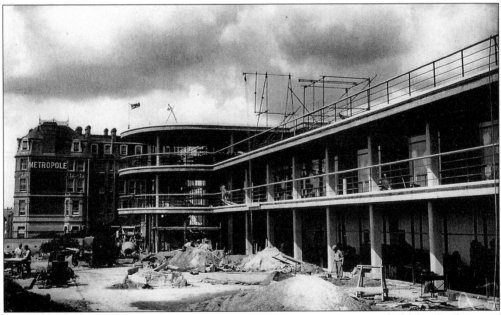

The De La Warr Pavilion under construction, 1935. A competition was held for the design of the new pavilion and it attracted 230 entries. The winning design was by the German architect Erich Mendelsohn with Serge Chermayeff. When built, the Pavilion was sandwiched between the Metropole Hotel and Marina Court; the architects envisaged both of these and the Colonnade eventually being replaced by Modernist structures.

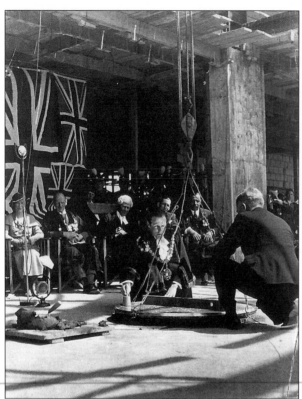

The ninth Earl De La Warr laying the commemorative plaque of the De La Warr Pavilion, 1935. The plaque is situated at the bottom of the Pavilion's spiral staircase.

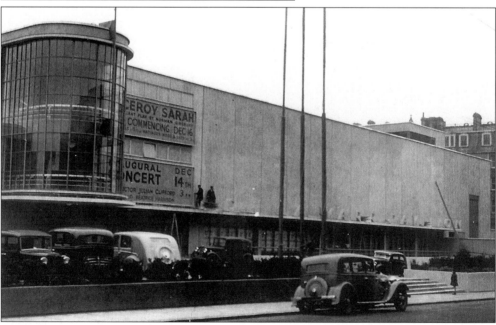

The De la Warr Pavilion just before it opened in December 1935. When the ninth Earl became mayor in 1932 he led a campaign for a new entertainment pavilion for the town. In line with his socialist views he wanted a 'people's palace' quite different from the elitist Kursaal that his father had built to entertain the upper classes.

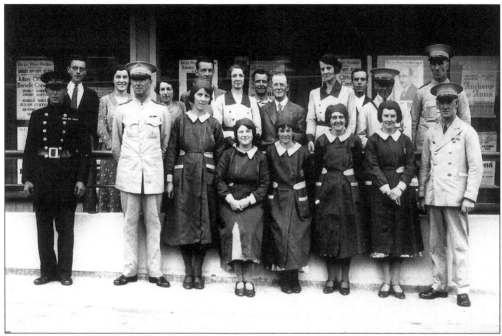

De La Warr Pavilion staff at its opening, 1935. The man in the middle of the back row is Mr Cecil Rhodes, the entertainment manager, and on his right is Mrs Hickmott, the housekeeper.

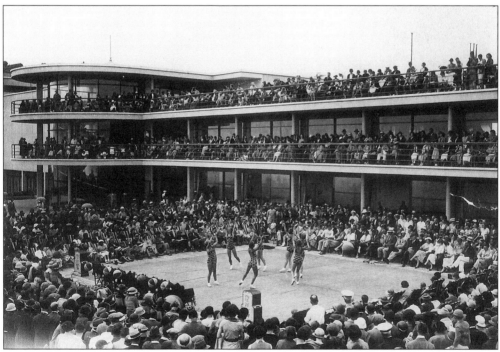

The Daily Mirror Eight perform on the terrace of the De La Warr Pavilion, 1936.

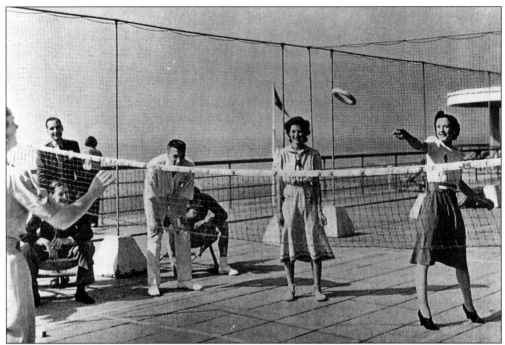

Deck quoits on the roof of the De La Warr Pavilion, *c.* 1939. Modern health and safety legislation forbids the use of the Pavilion's roof but it was originally intended as a public area for games and sunbathing, much like the deck of an ocean liner.

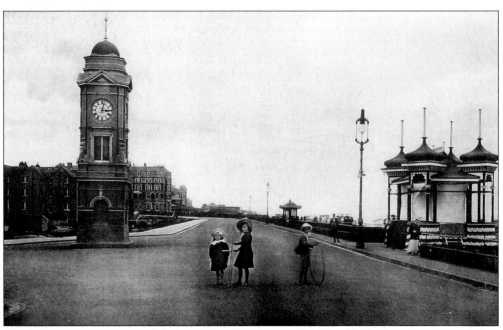

Clock Tower and ornamental shelter, West Parade, *c.* 1904. The Clock Tower was intended to commemorate the coronation of Edward VII in 1902 but was not completed until 1904.

Five
Collington, Cooden,
Little Common
and Sidley

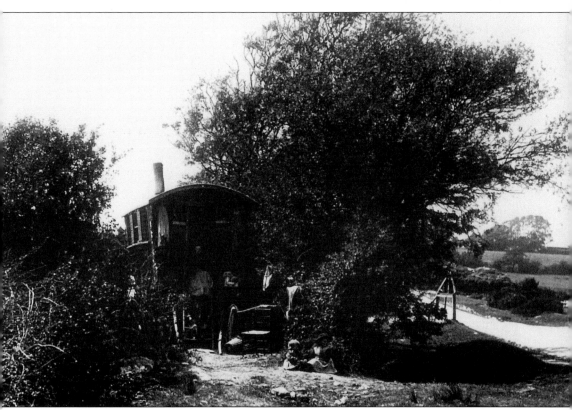

Gypsies encamped by Bexhill Down between Beaconsfield Terrace and Collington Lane, c. 1900.

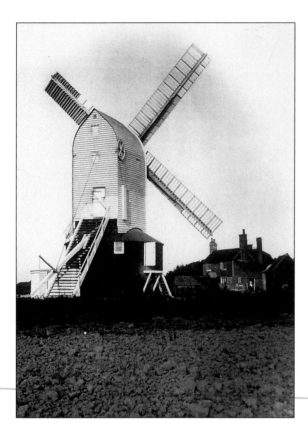

The Down Mill, *c*. 1920. The mill was built in 1735 and operated until 1928. It then fell into disrepair and finally collapsed in 1965. The Hoad family bought the mill in 1857 and were its last owners. In 1960 the artist L.S. Lowry visited Bexhill and painted the mill in its last stages of decay. His painting now hangs in Bexhill Museum.

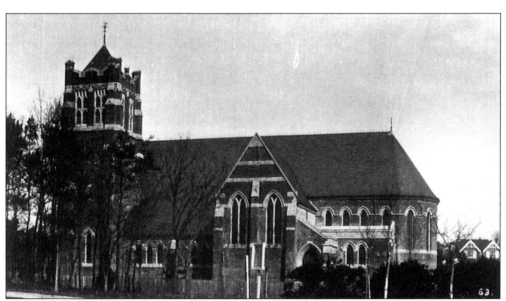

St Stephen's church, Bexhill Down, *c*. 1910. The church replaced the Down Mission Hall when it was consecrated in 1900. The acre of land on which it was built, the cost of construction and an endowment were all provided by John Lambert Walker of Woodsgate.

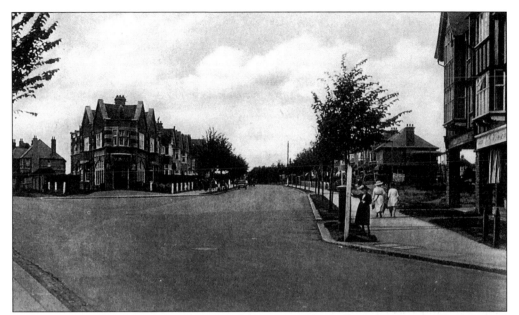

Collington Avenue, c. 1920. At the turn of the century the Collington estate had been owned by Daniel Mayer; he built the impressive Collington Manor on the site of Collington Farm. The house was bought by the Middlesex Memorial Fund in 1930 and used as a school; it was demolished in 1968. Many of Bexhill's independent schools were in Collington Avenue.

Collington Pond, c. 1905. The pond has long since gone and was in the area that is now Walton Park.

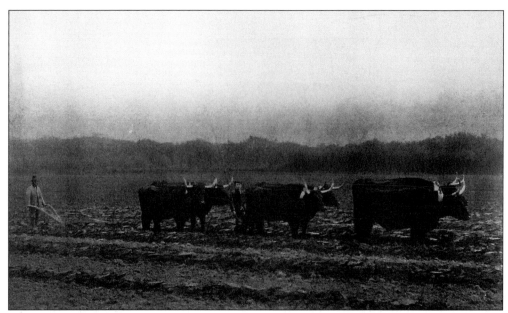

An ox team ploughing at Collington Wood, *c.* 1892. The ploughman is Nelson Spray and the boy Arthur Unstead. The oxen were called Diamond, Duke, Fortune, Luck, Linnet and Lark. Ox teams were often used on farms in this area until the turn of the century.

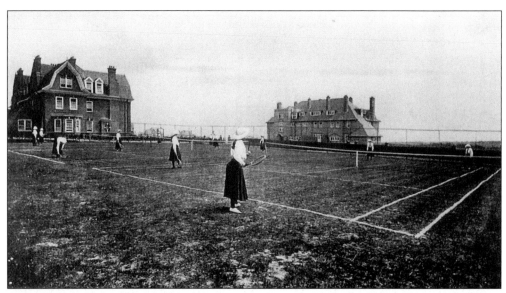

St John's school for girls, Collington Avenue, *c.* 1912. The school moved to Bexhill from Redhill in 1910. It was evacuated during the Second World War and did not reopen. In 1947 the Royal Merchant Navy used the building as a junior school. The imposing office block that now occupies the site was built in 1972-73 by the Hastings and Thanet Building Society and is now called Conquest House, the headquarters of Hastings Direct.

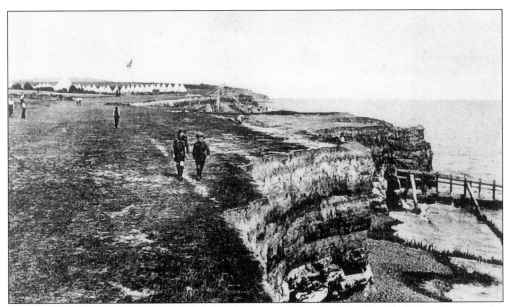

Boy Scouts at Cooden Cliffs, *c*. 1910. The Kangaroo Patrol of the 1st Bexhill troop were the Town's first scouts in 1908.

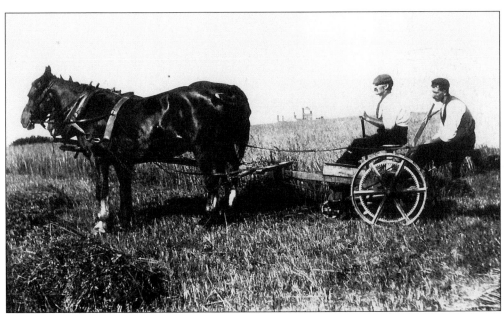

Jack Freeman and Bert Parks mowing oats with the horses Diamond and Champion, *c*. 1900. Cooden Mount is in the background. During the First World War the field became part of Cooden Camp.

Cooden Moat, showing the moat filled with Second World War concrete tank traps, c. 1947. The moat is all that is left of a manor house built by the Coding family in the thirteenth century. The land had been given to John de Coding in the eleventh century by Robert, Count of Eu, lord of the Rape of Hastings and half-brother of William the Conqueror.

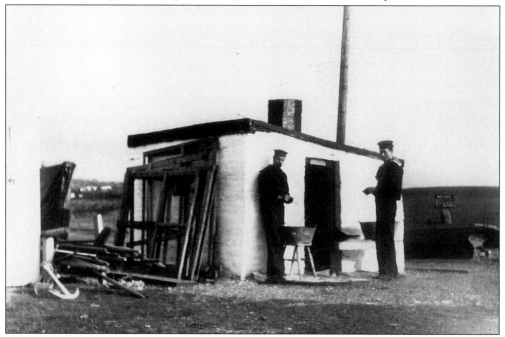

'The Bricks', c. 1896. This was a shelter used by coastguards and fishermen at Cooden. It was built from the remains of Martello Tower No. 50 which was used as a target for an artillery demonstration in 1860.

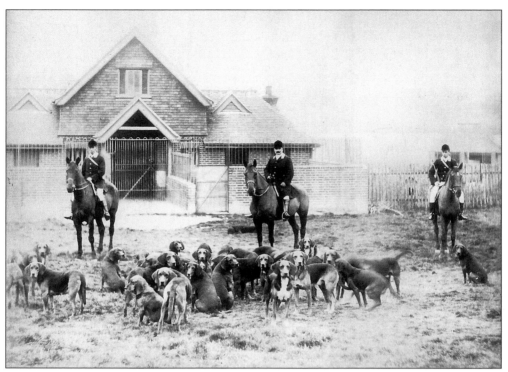

Kennels of the Bexhill Harriers at Cooden, *c.* 1900. The kennels were built in 1891 by Viscount Cantelupe and the foundation stone was laid by his fiancée, Muriel Brassey. The dogs in the foreground are Southern hounds, a breed that is now extinct.

Cooden Beach Hotel, *c.* 1935, shortly after its conversion from a group of shops. Note the trolleybus cables overhead. Trams and the trolleybuses that replaced them in 1928 turned around at this point to go back to the Metropole Hotel.

Lower Barnhorn Farm, *c.* 1900.

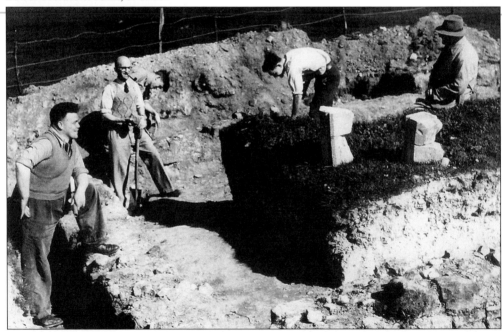

Excavation at Northeye, the Bexhill Museum Association's dig, 23 April 1952. On the left is Barry Lucas, the archaeologist who organized the dig, and on the right is Henry Sargent, curator of Bexhill Museum. Northeye is a deserted settlement on the marshes below Barnhorn. The site was abandoned in the seventeenth century and the remains of its chapel stood until the mid-eighteenth century. Now only indistinct earthworks remain of a village that was once a limb of the Cinque Ports.

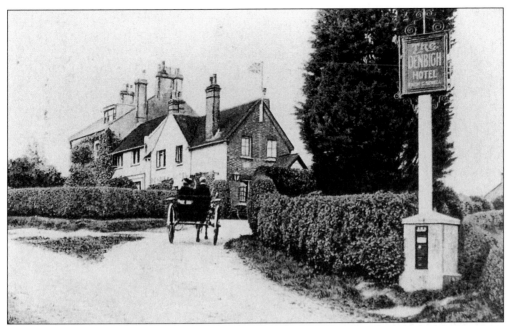

The Denbigh Hotel, *c.* 1910. The Denbigh is on a hill overlooking Little Common and was one of the original inns, along with the Bell, Black Horse and Star, that pre-dated the late Victorian resort of Bexhill-on-Sea.

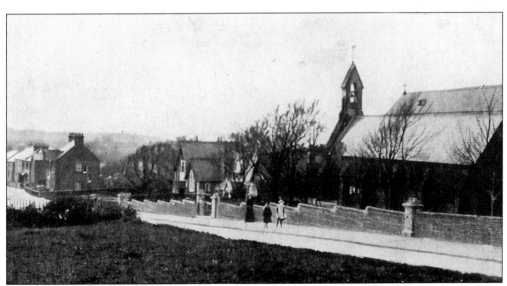

St Mark's church, Little Common, *c.* 1900. The church was begun in 1842 using bricks from Martello Tower No. 42. The parish was created in 1857 and the church enlarged the following year. The south aisle was added and the nave extended in 1885 and the Lady Chapel, new vestry and north aisle were built in 1931.

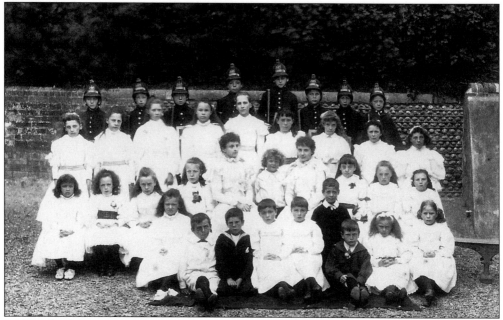

Staff and pupils at St Mark's school, Little Common, *c.* 1900. Left to right, back row: Harry Page, Ted Elliott, Bernard Smith, Bert Longley, Bill Pierpoint, Ted Sargent, Jack Winborn, Fred Barnes. Third row: May Coleman, Bessie Thomas, Flourie Booth, Jessie Medhurst, Alice Coleman, Mabel McGredy, Lillie Elliott, Kate Harmen, Emily Eastwood. Second row: Phyllis Duke, Polly Chester, Flo Mitten, Ruth Sargent, Miss Kate Hawkins (teacher), Frank Duke, Miss Moria Hawkins (teacher), Kate Jenner, Annie Gillham, Flo Gillham. Front row: Maggie Bennett, Frank Cheal, Ralph Gillham, Lily Gillham, May Gillham, Sid Barnes, Will Sargent, (Elsie) Freda Spray.

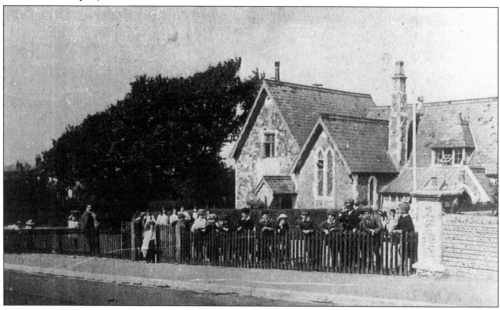

St Mark's Church of England school, Little Common, *c.* 1920. The school opened in 1855, was extended in 1863 and again in 1890. It closed in 1961 and was demolished in 1967.

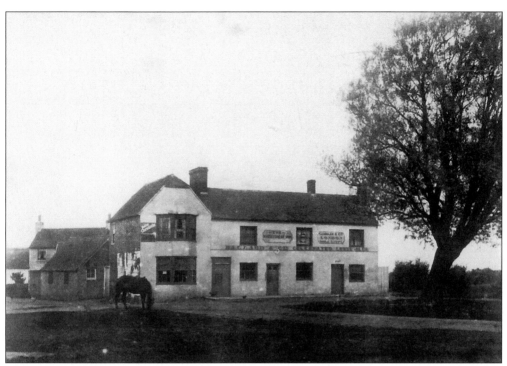

The Wheatsheaf Inn, Little Common, *c.* 1880. The photograph shows the building before it was substantially modified in 1886.

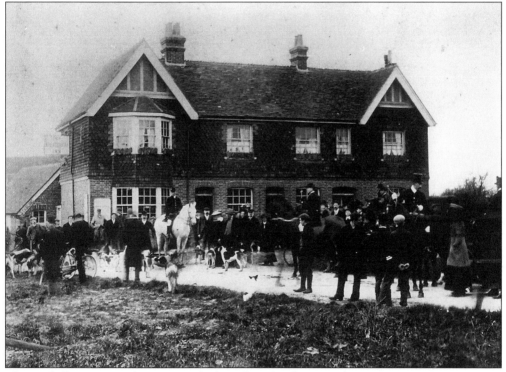

The Bexhill Harriers gathering outside the Wheatsheaf Inn, Little Common, *c.* 1890.

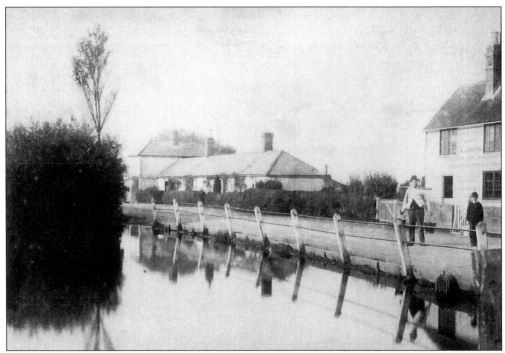

Little Common Pond, 1887. On the left is Freshwater Cottage and on the right is Pond Cottage. The pond, which was liable to flood, has long since disappeared and the land has been built upon.

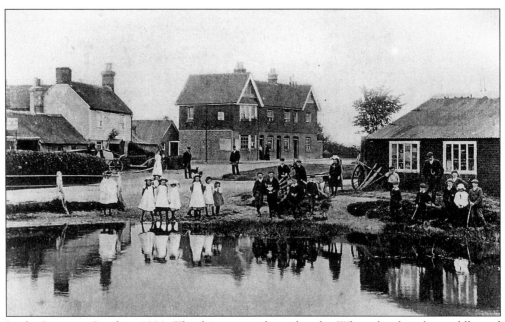

Little Common Pond, c. 1900. The forge is on the right, the Wheatsheaf in the middle and Dicks' wheelwright's on the right.

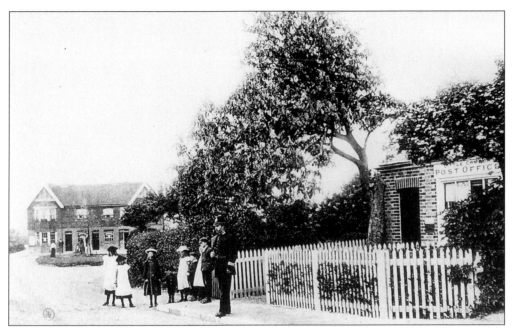

Little Common post office, Church Hill, *c.* 1905. Over the years the post office moved to a number of different locations in the village. The Wheatsheaf is in the background.

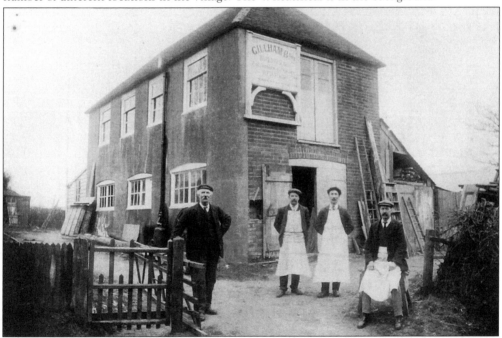

The Gillham brothers' workshop, Cooden Down, *c.* 1900. From left to right are George Gillham, William Gillham, Thomas Gillham and Stephen Plum. George's grandfather George 'Smack' Gillham was the leader of the Little Common gang of smugglers and kept a detailed account book of their contraband from 1825 to 1827. The most famous encounter between the local smugglers and blockade men took place at Sidley Green in 1828, where two smugglers and one blockade man were killed. Eight smugglers were caught and transported to Australia.

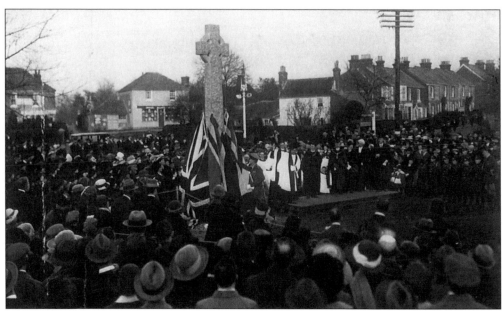

Unveiling the War Memorial at Little Common, 21 November 1920.

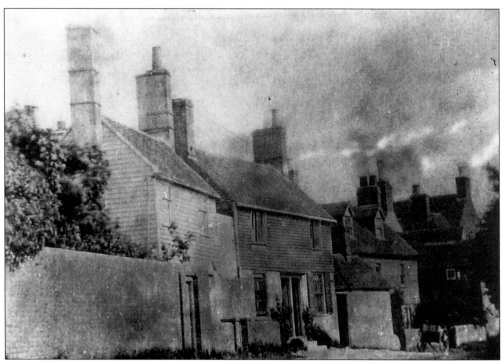

Holliers Hill, *c.* 1875. These cottages were built around 1806 and only two now survive. On the left is April Cottage (now Kirklee Cottage) and on the right is a butcher's shop that operated for over one hundred years until its closure in 1989.

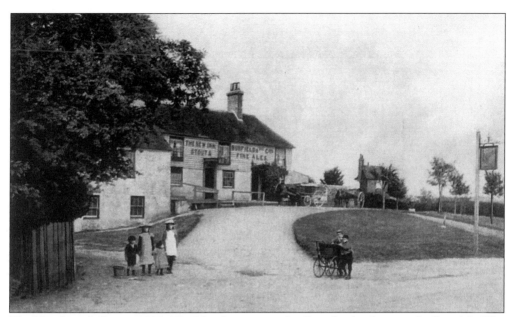

The New Inn, Sidley, *c*. 1900. The New Inn was, and still is, the focal point of village life. The inn was known as The Five Bells in the mid-eighteenth century.

Children playing on 'The Pond', Sidley, 1920. This was a grassed area behind the New Inn and had been the village pond before it was filled in to create a children's play area. The children are, from left to right: Allan Tidd, George Tidd, Doris Wood and Evan Kiff.

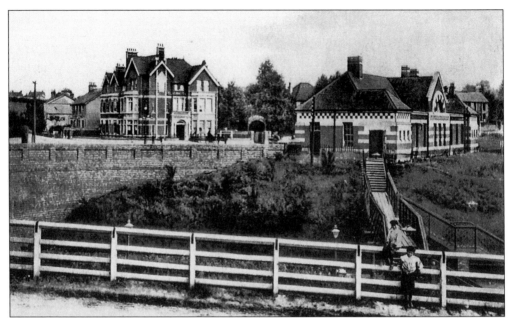

Sidley Station, *c.* 1909. The footbridge that crossed the line and gave access to the sunken platform is clearly shown. The Pelham Hotel is in the background; it was put up in around 1902 by J.P. Goodwin who also built the York Hall.

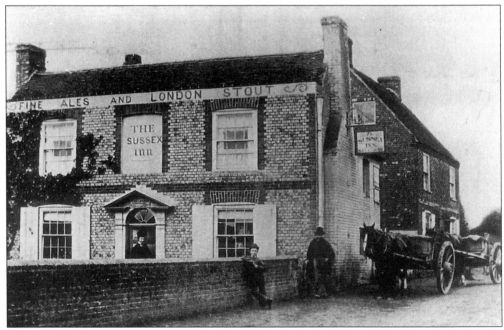

The Sussex Inn, Sidley, *c.* 1880. This stood on a site next to the Sussex Hotel which replaced it in 1900. The woman in the doorway is thought to be Annie Hammond (*née* Balcombe).

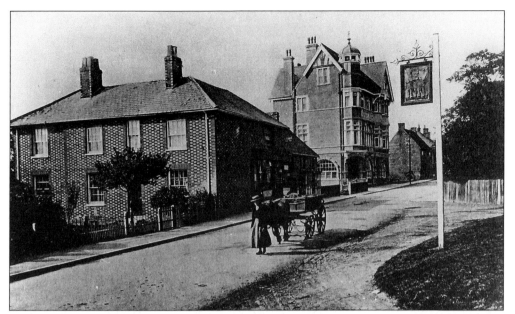

Wicken's general store and post office and the newly built Sussex Hotel, Sidley, *c.* 1900. The Sussex Hotel was designed by Henry Ward, the Hastings architect who also designed Bexhill Town Hall, St Stephen's church and the Congregationalist church in London Road. The photograph was taken from outside the New Inn.

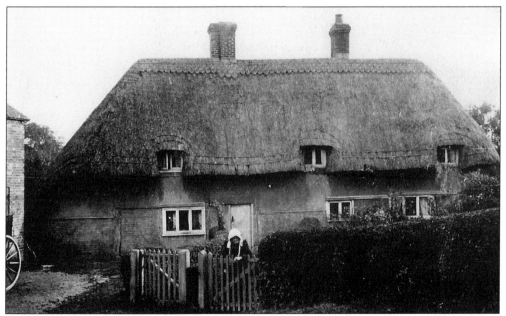

Sidley's last thatched cottage, *c.* 1900; it was demolished in the 1950s. The cottage was set back beside the Sussex Hotel. The woman in her traditional 'Sussex bonnet' was Mrs Turner.

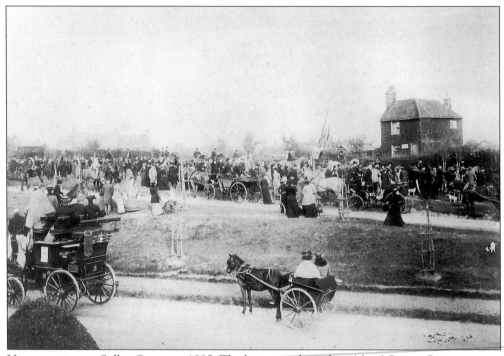

Hunt meeting on Sidley Green, c. 1885. The house on the right is No. 6 Sprays Cottages.

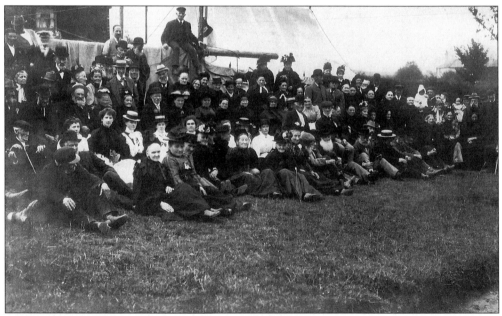

Coronation dinner for old folk on Sidley Green to mark the coronation of Edward VII, 9 August 1902. There were 180 elderly residents present and each was given a photograph of the King and Queen. The marquee proved to be too small and another was lent by John Lambert Walker of Woodsgate and an awning was rigged between them.

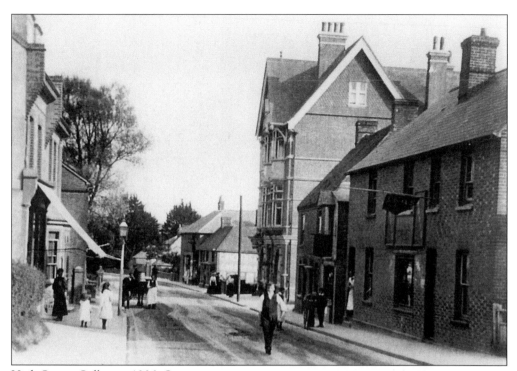

High Street, Sidley, *c.* 1906. On the right are Laurel Cottages including W.W. Sharpe's baker's shop and tea room. From 1921 until it was demolished for road widening in 1961 it was Arscott's the baker's.

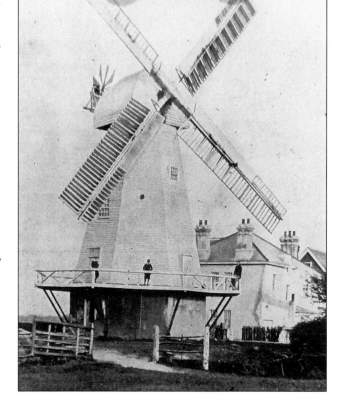

Pankhurst's Mill, Ninfield Road, Sidley, *c.* 1900. This smock mill was one of three in Sidley and was there from at least 1813. It was sold in 1928 after the death of its last miller William Pankhurst, dismantled and re-erected at Stocks Green near Leigh in Kent. It collapsed in 1960.

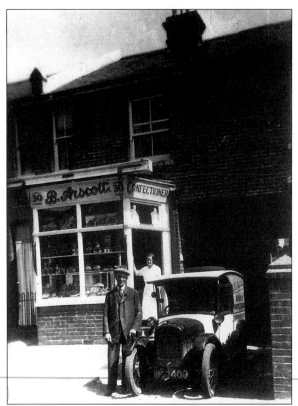

The Honies Bakery, Beaconsfield Road, c. 1930. In the photograph are Bert Arscott and his daughter Doris who later married Mr Skellett. The bakehouse behind the shop also served his other shop in Sidley High Street. Bert Arscott was president of Sidley Working Men's Club and of the Sidley Football Club for many years.

Turner's Forge, Sidley, c. 1896. The forge stood in Sidley High Street for centuries before it finally closed in 1957. Blacksmith Joshua Turner (far right) was apprenticed to Alfred Thomas here in 1856 at the age of seventeen and was succeeded by his son Stephen (far left), who was followed by Stephen's son Jack (blacksmith) and Stephen Turner junior (wheelwright).

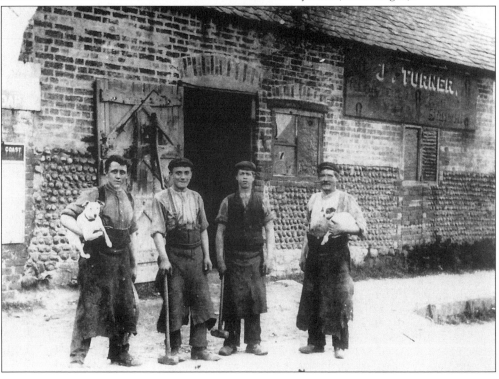

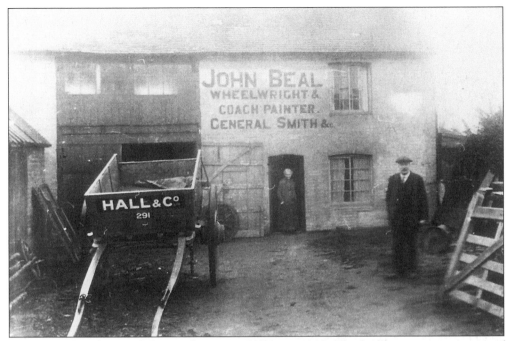

Beal's wheelwright's workshop and cottage, Sidley, *c.* 1910. The buildings are now a pair of cottages and are some of the few old buildings remaining in Sidley. John Beal and his wife are shown here; they also had a forge opposite the Sussex Hotel and, as horse traffic declined, a general engineering and cycle shop.

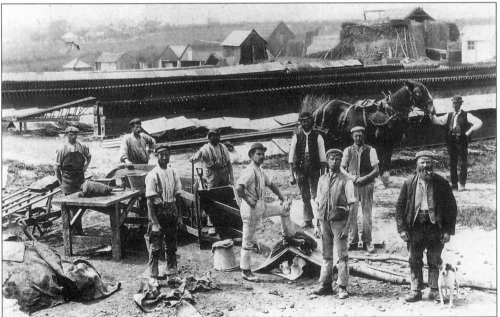

Adam's brickyard, Sidley, *c.* 1890. From left to right: Mr Deeprose, Mr J. Ransom, Mr Sinden, Mr Goldsmith, George Adams, Mr White, Stephen Adams, -?-, Mr G.T. Cramp Snr with his dog Pepper, and finally Mr Honeysett holding the horse. Behind the men long lines or 'hacks' of bricks are being allowed to dry before firing. Brickyard Farm is in the background.

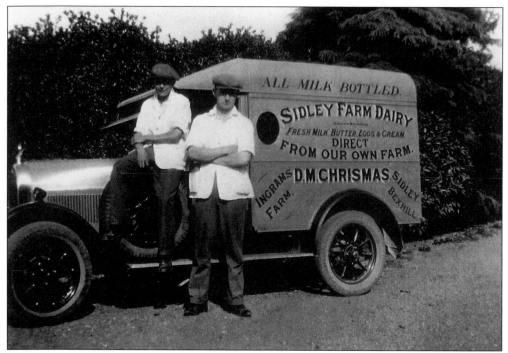

Sidley Farm Dairy's van, 1920s. Ingrams Farm became the site of the first of the post-Second World War housing estates.

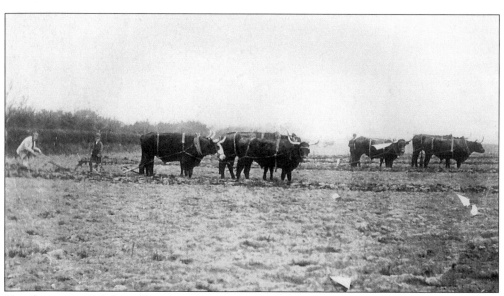

Plough team at Pebsham Farm, c. 1899. Oxen were commonly used on local farms until the turn of the century.

Six
Transport

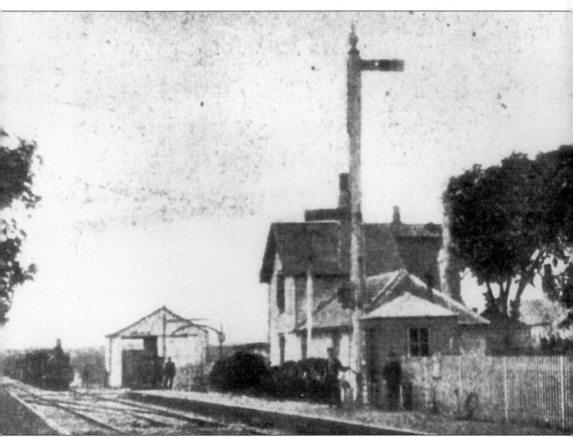

Bexhill's first railway station, *c.* 1880. This was a halt on the north side of the line and stood roughly where Sainsbury's car park is today. The line was put through in 1846 and the station was built at this time. Bexhill was still a small inland village and some distance from the station. A track followed the line east and joined Sea Lane (now Sea Road) and another ran north west to Belle Hill. This became Station Road and is now London Road.

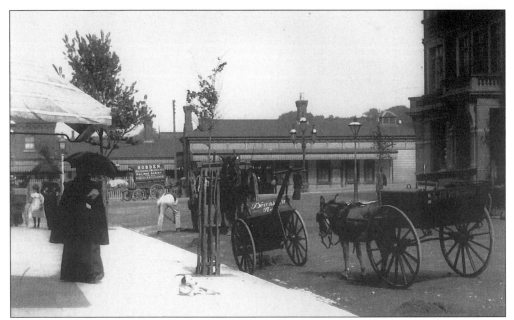

Devonshire Square station, *c*. 1896. The station site is in the background and the Devonshire Hotel to the right. The station was opened in 1891 to replace the halt that was built in 1846. The present station was opened in 1902.

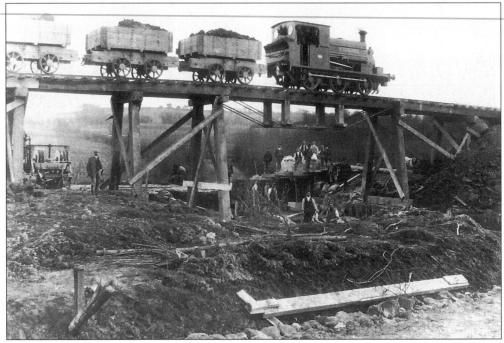

Construction of the Crowhurst Line. A cattle arch is being put in between Glovers and Actons farms in Sidley. Work began on the line in 1897 and it was opened in 1902. The engine on the temporary railway line shown here was the *St Leonards*, one of seven used by the contractors, Messrs Price and Reeve. The Crowhurst Line was closed in 1964 as part of the Beeching Plan and Bexhill's direct line to London was lost.

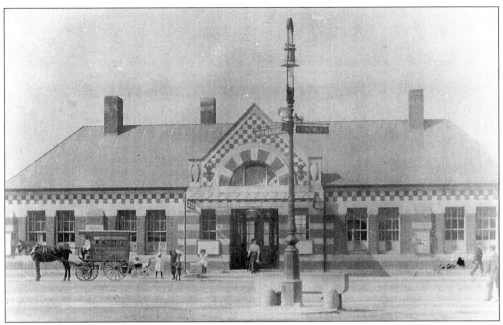

Sidley station, *c.* 1905. The station was opened in 1902. The line was below road level and the station was reached by a footbridge. The horse drawn van belonged to W.W. Sharpe, the baker. The station was closed during the Second World War and after the war a small ticket office remained while the rest of the building became a garage. The site is now a filling station.

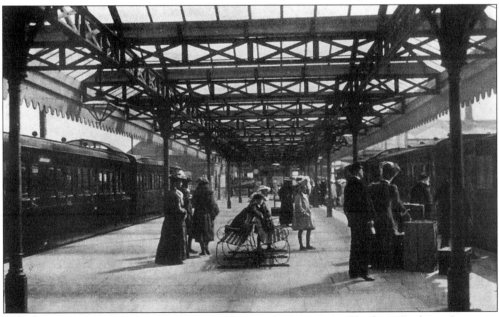

Bexhill West station platform, *c.* 1905. The South Eastern & Chatham Railway Company started to build the Crowhurst Line in 1898 and it was opened with the new Bexhill West station in 1902. The line linked Bexhill, via Sidley and Crowhurst, to Battle, providing a direct line to London. In 1964 the line was closed and easy access to the capital was lost.

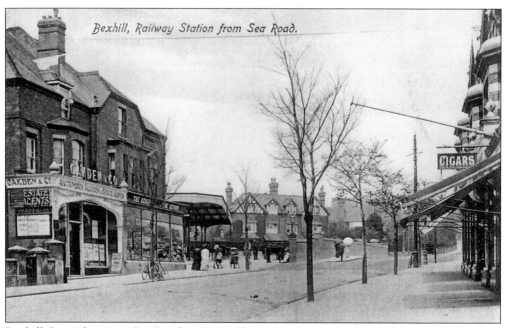

Bexhill, Railway Station from Sea Road.

Bexhill Central station, Sea Road, *c.* 1910. The station was opened in 1902, moving east from its previous site in Devonshire Square.

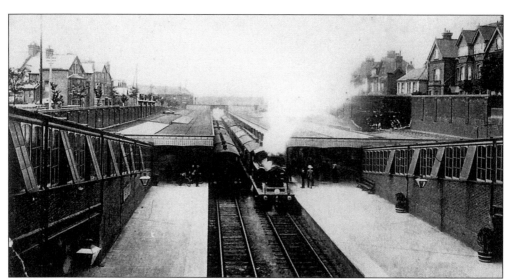

Bexhill Central station, *c.* 1908. The original station faced onto Devonshire Square and its platforms were retained and joined onto the end of those of the new station.

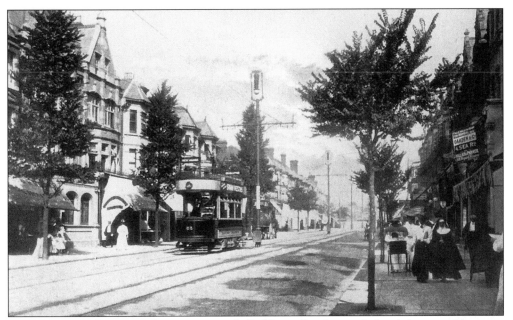

Devonshire Road, *c.* 1908; the junction with Parkhurst Road is just behind the tram. Note the combined street lights and tram cables in the middle of the road.

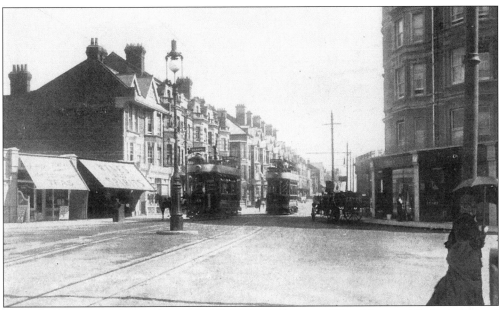

Trams by the Metropole Hotel, *c.* 1908. The tramway between West Marina in St Leonards and the Metropole Hotel in Bexhill opened in 1906 and later that year the tramway was extended to Cooden Beach.

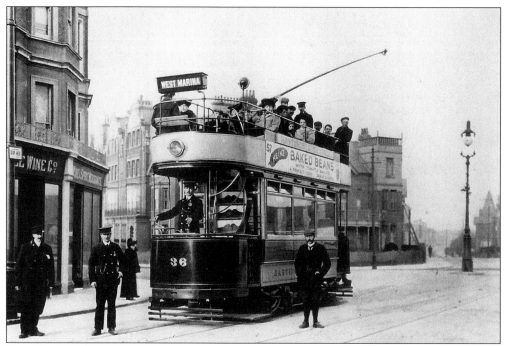

Tram No. 36 outside the Metropole Hotel, 1906. The lamp post stands on the site now occupied by the Sackville Road roundabout.

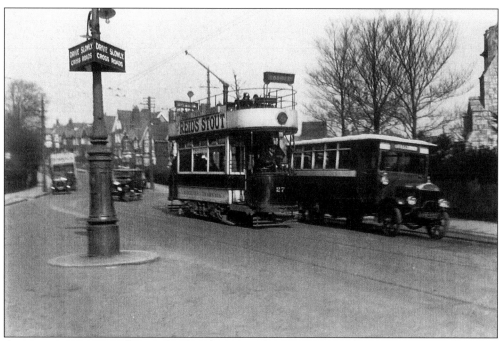

A tram passing an omnibus on Sea Road, 10 March 1925. In 1901 the Bexhill Motor Company operated the first omnibus service. Tram services started in 1906 and were replaced by trolley buses in 1928.

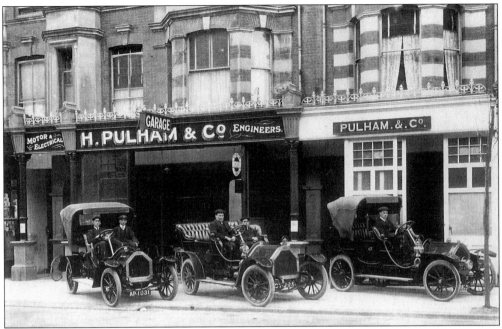

Pulham's garage, Sackville Road, *c.* 1910. Herbert Pulham experimented with running a double-decker bus in 1913 but abandoned the scheme when it would not fit under the Sackville Arch.

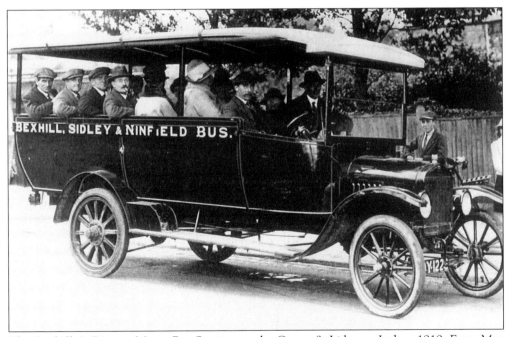

The Bexhill & District Motor Bus Service run by Carter & Lidstone Ltd, *c.* 1919. From May 1919 the company ran omnibuses to the surrounding towns and villages. Carter & Lidstone's garage was in Green Lane, Little Common.

Marina Garage and Forte's ice cream parlour, Marina, *c.* 1920.

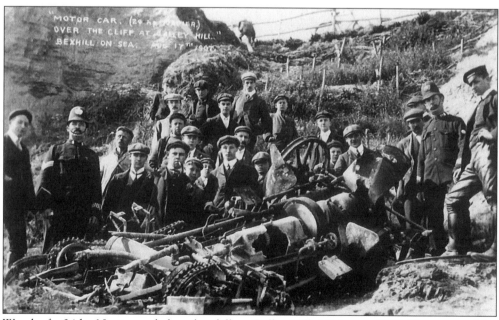

Wreck of a 24 hp Napier car below the cliffs at Galley Hill, 17 August 1907. The cause of the accident and indeed the fate of the driver are not recorded.

Seven
Sport

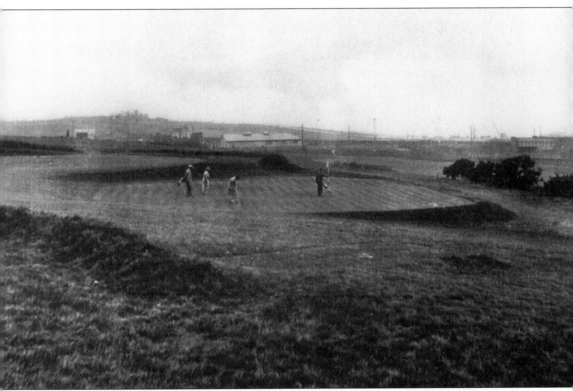

Golf course at Galley Hill, *c.* 1920. Undeveloped land on the eastern part of Earl De La Warr's estate was used as a golf course until the Second World War. Bexhill's first golf club was founded in 1880 using an old cottage on the site as a clubhouse and this was extended in 1912. The eighth Earl built the Cooden Beach golf course in 1911 and the Highwoods course opened in 1924.

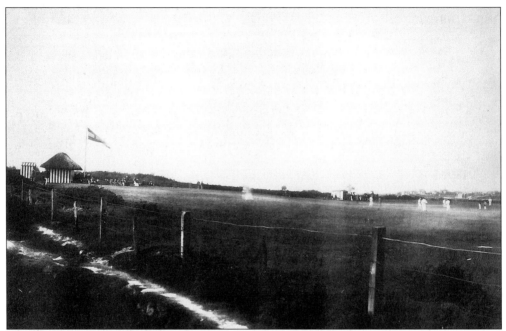

Bexhill cricket ground, The Down, *c.* 1892. This pitch dates from 1873 at least. In 1893 Viscount Cantelupe made his own cricket pitch in the Manor House grounds, where his eleven played against a South African team in 1894 and an Australian team in 1896.

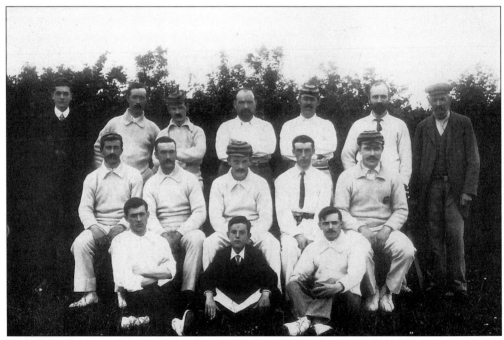

Bexhill Tradesmen's Cricket Club Wednesday team, 1906. Back row, from left to right: -?-, Mr W.R. Denman, Mr H.A. Long (?), Mr D.B. McGregor, Mr H.G. Budder, Mr Wickens, Mr Denman Snr. Middle row: Mr E.T. Coleman, Mr Franks (?), Ted Elliott, -?-. Front row: -?-, Mr Ball, -?-.

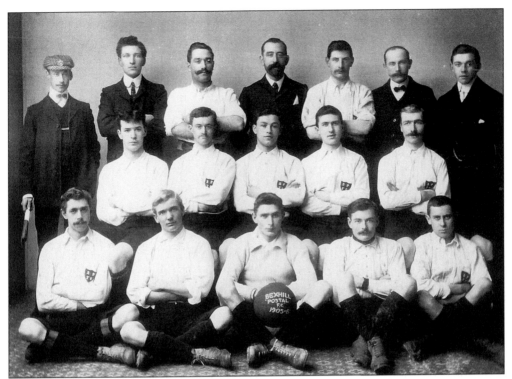

Bexhill Postal Football Club team, 1905-06. Bexhill's first club was founded in 1889.

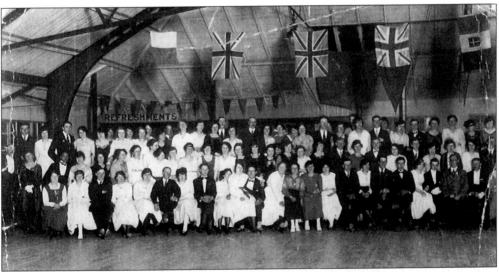

Bexhill Football Club's dance, 9 April 1920. The event was held in the roller skating rink in Buckhurst Road; soon afterwards the rink closed and was replaced by a garage. In 1937 the Ritz cinema opened on the site. It closed in 1961 and was later demolished. The site is now occupied by the telephone exchange.

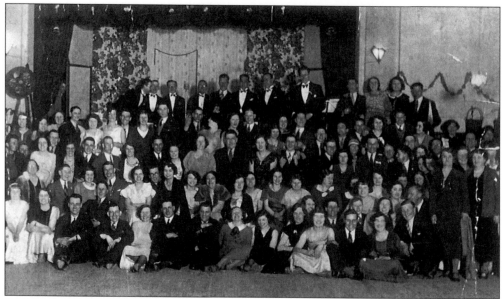

Bexhill Amateur Athletic Club dance in the York Hotel, London Road, 1937. The hotel was built in 1895 and was next to the York Hall which was one of the earliest venues for public meetings and entertainment in the new town, pre-dated only by Victoria Hall which was opened in 1887. In 1935 the York Hall became the Gaiety Cinema but closed after being bombed in 1940.

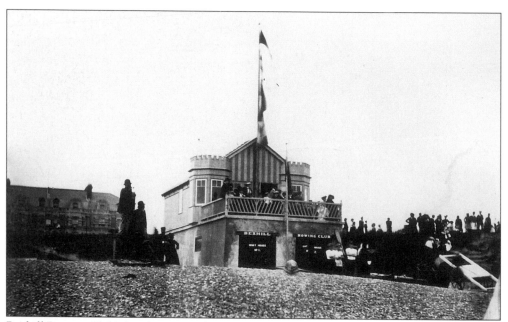

Bexhill Rowing Club's boathouse, on the west side of The Horn, *c.* 1895. The Rowing Club was founded in 1893 and held its first regatta that year. The boathouse in the photograph was destroyed by fire in 1900.

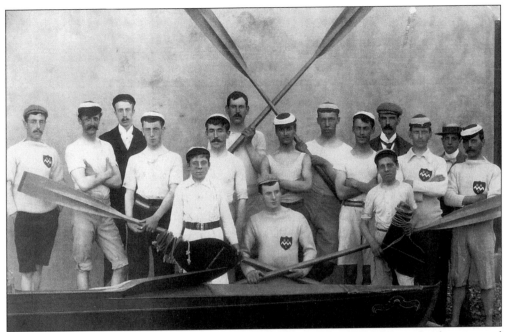

Bexhill Rowing Club in 1893, the year it was founded. The club's colours of red, green and white were chosen with the help of Lady Cantelupe, the future Lady De La Warr, and the boat shown here bears her name. The man between the crossed oars is Mr Warren and the man on the far left is Mr Moss Winborn who was Bexhill's first beach inspector.

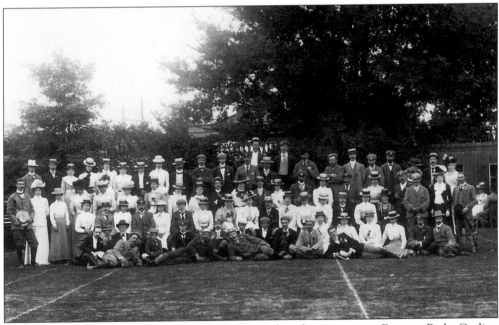

Bexhill Cycling Club, c. 1900. The club organized cycling events in Egerton Park. Cycling became a fashionable activity in the late 1890s and prompted Viscount Cantelupe to build his Bicycle Boulevard on the seafront in 1896 and hold cycling tournaments in the Manor House grounds.

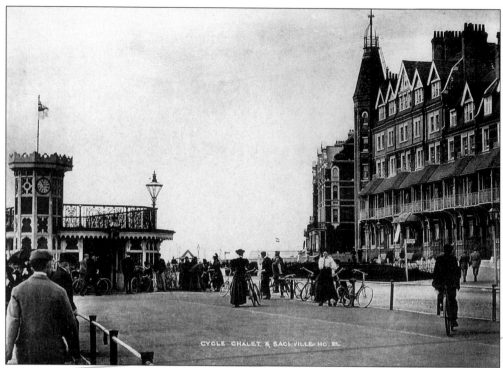

The Cycle Chalet, *c.* 1897. Bicycles could be hired from the Cycle Chalet for use on the Bicycle Boulevard and riding lessons were provided for new cyclists.

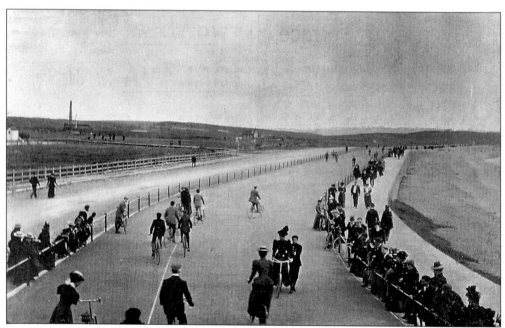

The Bicycle Boulevard, De La Warr Parade, *c.* 1900, seen from the terrace of the Cycle Chalet looking towards Galley Hill. The lady coming towards the Chalet appears to be taking lessons in cycling and is drawing a crowd. In the background are the golf links.

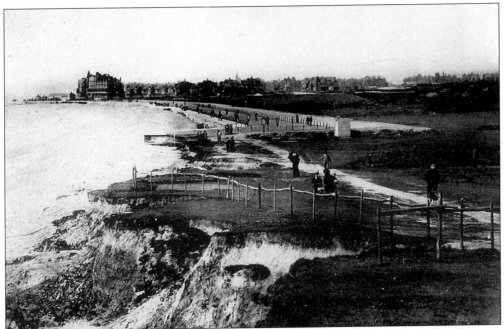

The far end of the Bicycle Boulevard at Galley Hill, *c.* 1897. A fee was charged to use the track and a fence surrounded it to prevent its use by non-paying cyclists. The cycle track was half a mile long and in 1902 became Britain's first motor-racing track.

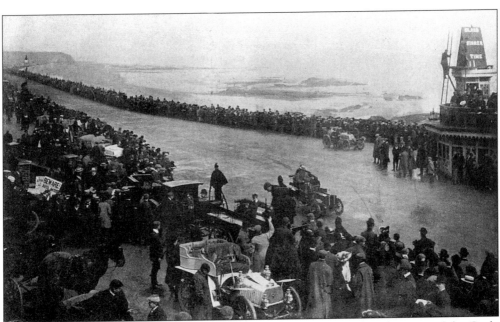

Britain's first race track, De La Warr Parade, 1902. Note the scoreboard on top of the Cycle Chalet. The races were organized by the eighth Earl De La Warr and the Automobile Club of Great Britain and Ireland. Note the hundreds of spectators on either side of the track.

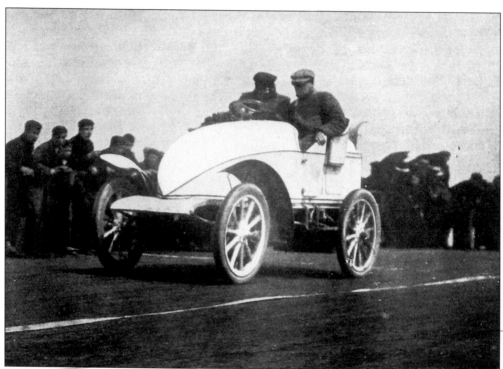

Leon Serpollet's steam car, the *Easter Egg*, on De La Warr Parade in May 1902. Serpollet recorded the fastest time at the 1902 event with just over 54 mph.

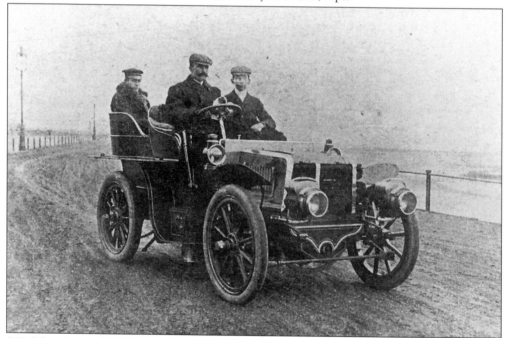

S.F. Edge driving his 16 hp Napier on De La Warr Parade, 1902. Edge was perhaps the best known of the British drivers at the 1902 event and won first prize for the appearance of his vehicle.

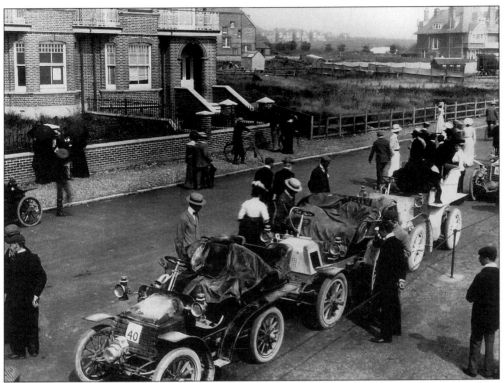

Cars parked on De La Warr Parade for the 1902 races. The house on the opposite side of the road is now The Bex.

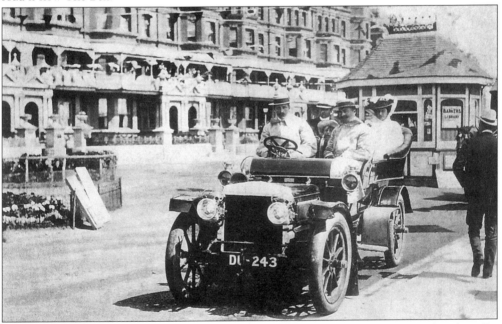

The eighth Earl De La Warr and Mr Stratton in an 18 hp Daimler at the 1904 speed trials on De La Warr Parade. There was no event in 1903 due to an injunction brought by Mr Mayner who objected to the 1902 races blocking access to his house on the seafront.

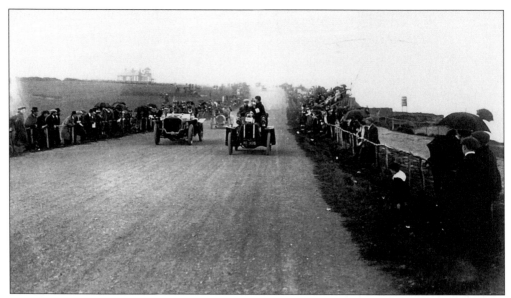

Motor racing on De La Warr Parade, 1904. Galley Hill with Sackville Lodge on top can be seen in the background. The track was one kilometre long from the foot of Galley Hill to opposite the middle of Marine Mansions. By 1907 serious racing at Bexhill had stopped, as cars had become too fast to race on the seafront, and the opening of the purpose-built circuit at Brooklands that year marked the beginning of a new era for motor sports in Britain. Earl De La Warr had planned his own circuit from Cooden to Pevensey in 1906 but this was never built.

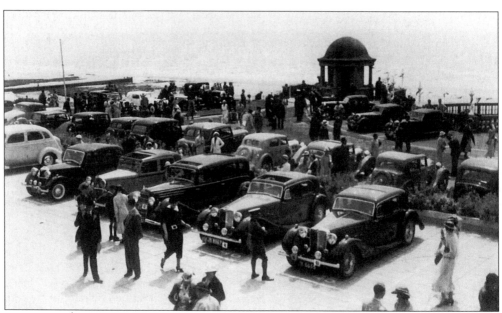

Concours d'Élégance held on the terrace of the De La Warr Pavilion in 1936. These car shows were held in 1934 and 1935 on De La Warr Parade, the final one being in 1936 at the newly opened De La Warr Pavilion.

Eight
Wartime Bexhill

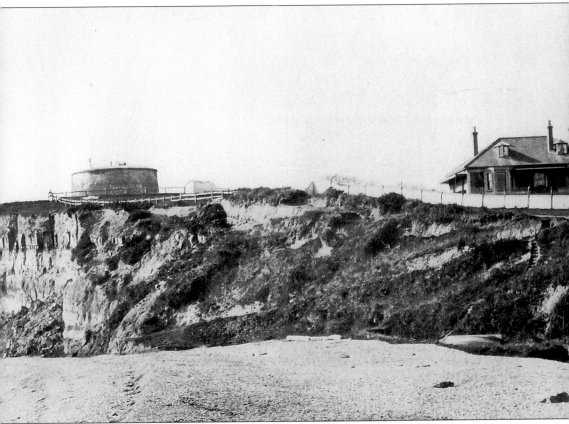

Martello Tower and cottage on the top of Galley Hill, *c*. 1890. This was Martello Tower No. 44 and was the only one in Bexhill to have a moat. By 1900 the tower had fallen into the sea. Construction of the towers began shortly after 1803 as a defence against a possible Napoleonic invasion. Each had a cannon on top and they were spaced so that their arcs of fire would overlap.

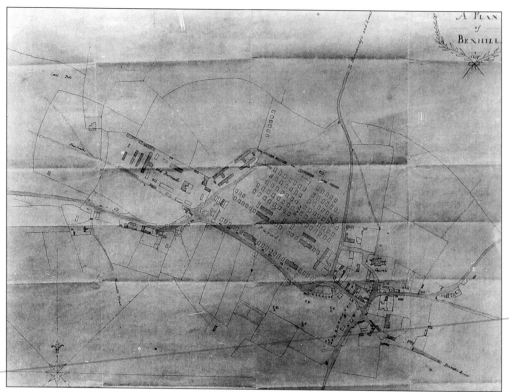

An 1808 map of Bexhill showing the barracks of the King's German Legion. The Legion came to Bexhill in 1804 and stayed until the Battle of Waterloo in 1815. There were about five thousand Hanoverian soldiers stationed in Bexhill at a time when there were only five hundred or so locals. The coal pits marked on the map are the result of an unsuccessful coal mining venture that took place at the beginning of the nineteenth century.

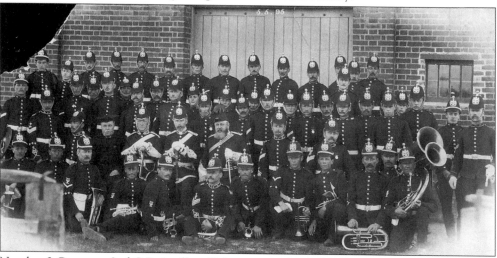

Number 3 Company 2nd C.P. Artillery Volunteers at the drill hall, 5 May 1895. Sitting to the left of centre are the eighth Earl De La Warr and Lord Brassey. This drill hall stood behind the Queen's Head pub on Belle Hill and access was from London Road. The present drill hall on Down Road was opened in 1901 by Lord Brassey.

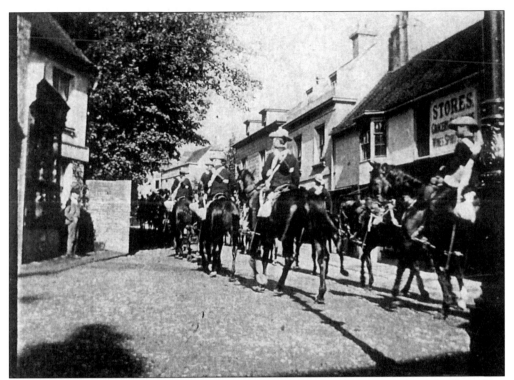

Troops riding down the High Street of Bexhill Old Town after their return from the Boer War, *c.* 1901.

Number 4 Company marching to Hastings, *c.* 1915; the gasworks and buildings in the background are where Ravenside now stands.

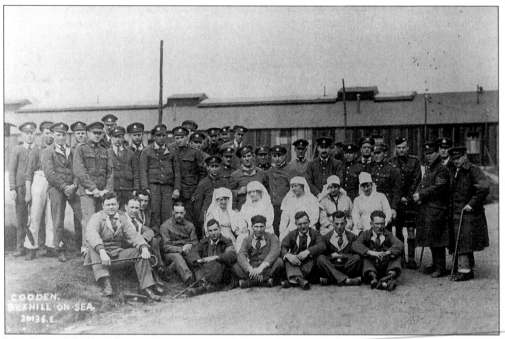

Members of the Royal Sussex Regiment and nurses from No. 38 Voluntary Aid Detachment at Cooden Camp, *c.* 1914.

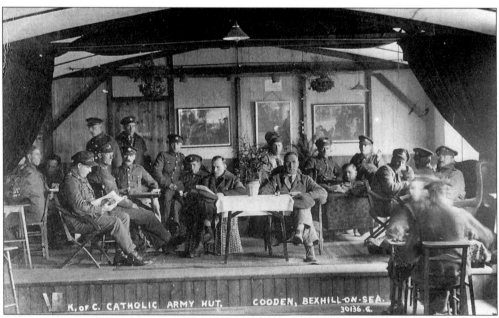

Some of 'Lowther's Lambs' in the 'King of Cooden's' Catholic army hut, *c.* 1914. 'Lowther's Lambs' were men from the 11th, 12th and 13th Battalions of the Royal Sussex Regiment who were raised by Lieutenant-Colonel Claude Lowther of Herstmonceux Castle. The 'King of Cooden' was Alderman Henry Young who lived at Cooden Mount and did much to help the soldiers who were trained at the camp.

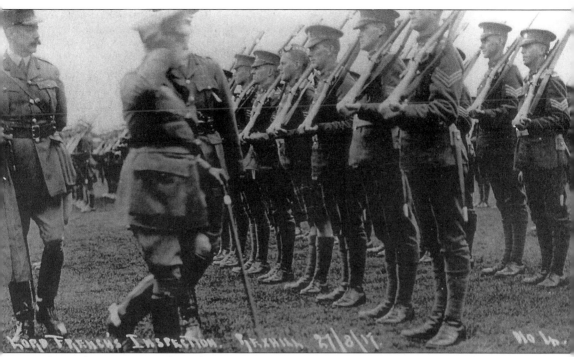

Lord French's inspection of Cooden Camp, 27 August 1917.

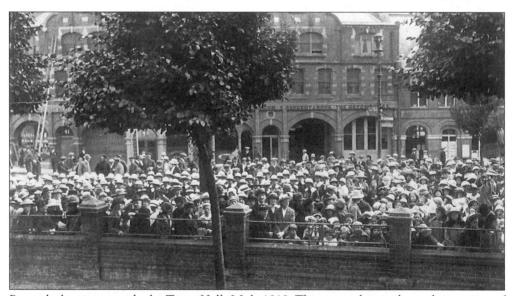

Peace declaration outside the Town Hall, 2 July 1919. This unusual view shows the premises of Solomon Sargent's removal firm in the background. These were bombed in the Second World War and the site is now occupied by Sainsbury's supermarket.

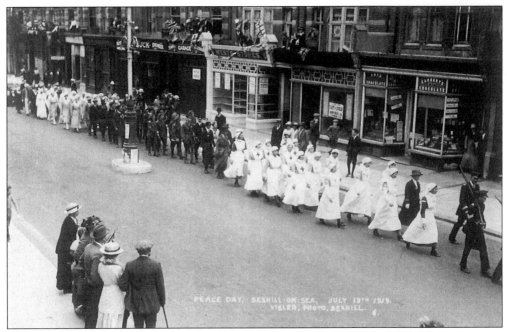

Nurses and soldiers march along Sackville Road on Peace Day, 19 July 1919. There were two military hospitals in Bexhill during the First World War, one at Cantelupe Road and the other at Cooden.

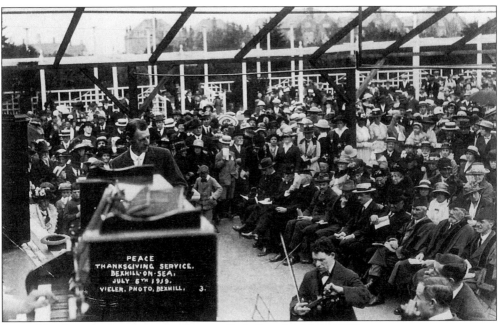

Peace Thanksgiving service in the Egerton Park Pergola, 6 July 1919.

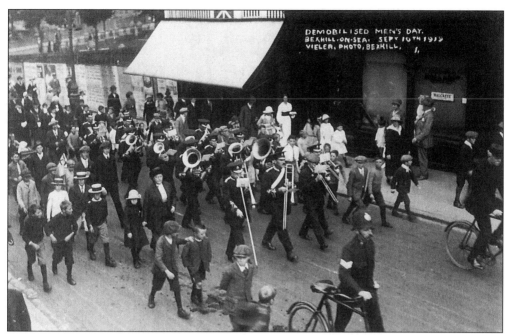

Demobilized Men's Day, 10 September 1919. The band and procession are passing up Buckhurst Road.

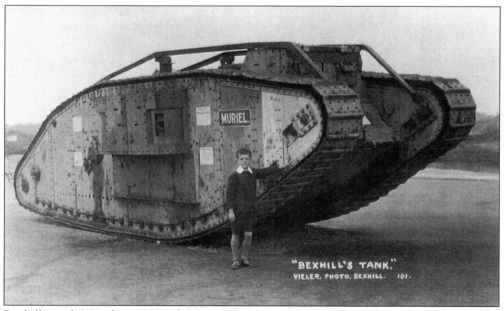

Bexhill's tank *Muriel*, c. 1920. This First World War tank stood on the seafront between the wars, and was given to Bexhill in recognition of the town's contribution to war savings. It was probably named Muriel after Lady De La Warr.

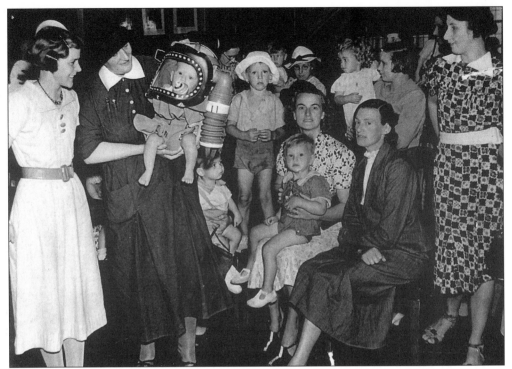

A baby's gas mask being issued to the Kiff family by Nurse Harris at the London Road Clinic in 1939.

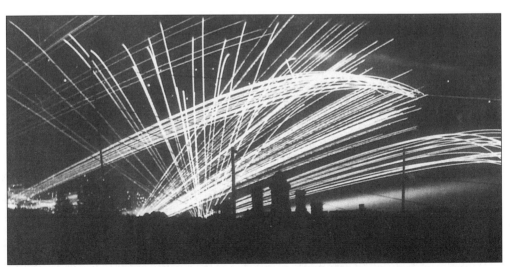

Anti-aircraft fire over Bexhill, 1940. During the Second World War Bexhill endured fifty-one air raids. Some 328 bombs and over 1,000 incendiaries fell on the town, killing twenty-one civilians and one soldier. The raids destroyed twenty-one buildings, seriously damaged 189 more and caused minor damage to another 2,735.

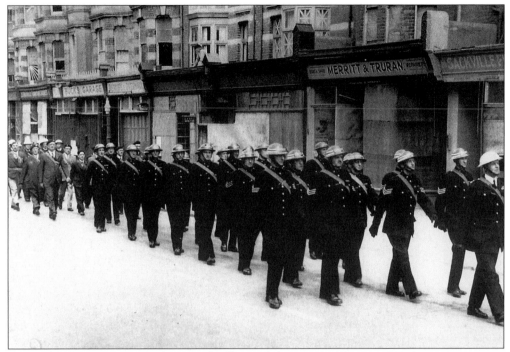

Civil Defence forces passing down Sackville Road during War Weapons Week in 1941.

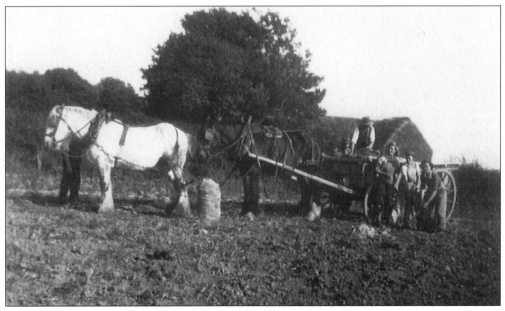

Land Army girls harvesting potatoes on Cobb's Hill Farm, *c.* 1940.

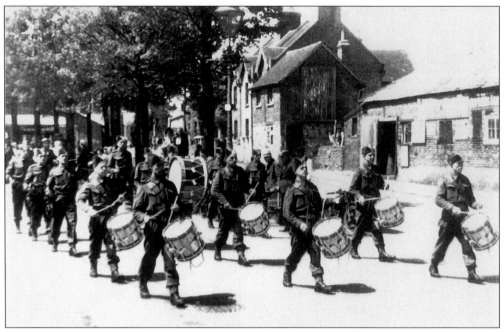

Canadian soldiers, the Calgary Highlanders, marching through Sidley, *c.* 1942. The soldiers were stationed in Bexhill and Little Common. The forge is on the right.

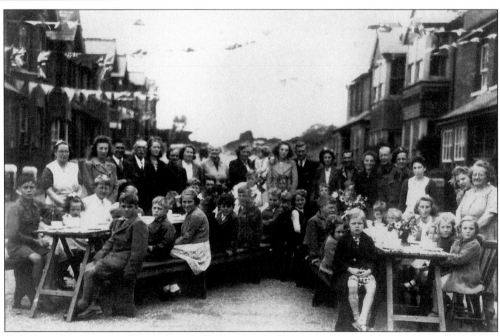

Victory street party in North Road, Sidley, 1945. The terraces were built on farm land for workers employed in the construction of the Crowhurst Line.